Family Secrets

Biographical note

Annette Kuhn is Professor of Film Studies at Lancaster University, UK, and an editor of the journal *Screen*. Her publications include *The Power of the Image: Essays on Representation and Sexuality*, *Cinema, Censorship and Sexuality, 1909 to 1925*, and, as editor, *Alien Zone: Cultural Theory and Contemporary Science Fiction Cinema* and *Alien Zone II: The Spaces of Science Fiction Cinema*. Her latest book is *An Everyday Magic: Cinema and Cultural Memory*.

Family Secrets

Acts of Memory and Imagination

NEW EDITION

◆

ANNETTE KUHN

VERSO

London • New York

First published by Verso 1995
New edition first published by Verso 2002
© Annette Kuhn 1995, 2002
All rights reserved

Verso
UK: 6 Meard Street, London W1F 0EG
US: 180 Varick Street, New York, NY 10014–4606

Verso is the imprint of New Left Books

ISBN 1–85984–406–5

British Library Cataloguing in Publication Data
A catalogue record for this book is available from the British Library

Library of Congress Cataloging-in-Publication Data
A catalog record for this book is available from the Library of Congress

Typeset in Bakserville by M Rules
Printed and bound in Great Britain by
Biddles Ltd, Guildford and King's Lynn
www.biddles.co.uk

Contents

Acknowledgements

Family Secrets had a prodigiously long gestation. The project, conceived soon after my mother died in the summer of 1987, suffered many ups and downs, and was even at one point abandoned. Blocks, internal and external, ranged from the travails of self-censorship and self-doubt (what right have I to subordinate history to my own puny existence?) and the impediments to any real reflection thrown up by the day-to-day demands of an academic job, to the death in 1992 of one of the project's 'angels', Jo Spence. Happily, however, I enjoyed the encouragement of many friends and colleagues and the support of several institutions. Without their help, the project would have foundered long ago.

For many and varied forms of inspiration, example, encouragement and practical assistance, my thanks go to: Paola Bacchetta, Connie Balides, Cecilia Barriga, Patrick Brennan, Philippa Brewster, Charlotte Brunsdon, Linda Callahan, John Caughie, Pam Cook, Anne Ferguson, Penny Florence, Alan Fountain, Ann Game, Annette Hamilton, Jane Hindle, Vijay Kumar, John Lechte, Jan McDonald, Paula Mark, Rosy Martin, Ruth Petrie, Rosemary

Pringle, Susannah Radstone, Dee Reynolds, Colin Robinson, Carol Shea, Jo Spence, Jo Stanley, Margot Waddell, Glasgow University Photographic Unit, Mount Holyoke Faculty Film Seminar, National Film Archive, students in 'Autobiography and Female Identity' (a class I taught at the City Literary Institute in London), and the many people who have offered comments and suggestions at the seminars and lectures at which parts of this book have been presented.

The Department of Anthropology at Macquarie University and the Five College Women's Studies Research Center at Mount Holyoke College conferred research fellowships, respectively in 1990 and 1994, which considerably facilitated progress with the project. The latter was supported by a Fulbright Senior Research Scholarship.

Earlier versions of 'She'll Always Be Your Little Girl . . .', 'The Little Girl Wants to be Heard', 'A Credit to Her Mother' and 'From Home to Nation' have been published respectively in *Family Snaps: the Meanings of Domestic Photography*, edited by Jo Spence and Patricia Holland (London: Virago, 1991); *Screen*, vol. 33, no. 3 (1992); *Feminist Subjects, Multi-Media*, edited by Penny Florence and Deirdre Reynolds (Manchester: Manchester University Press, 1994); and *Memory and Methodology*, edited by Susannah Radstone (London: Berg, 2000).

For permission to reprint photographs, thanks are due to Birmingham Museums and Art Gallery, Hulton Deutsch Collection Ltd, Times Newspapers Ltd, and the Robert Hunt Library.

Above all, I shall remain forever in debt to my late father, Henry Philip Kuhn, from whom I inherit an abiding fascination with and love of photography. It is thanks to his skills and enthusiasms as a photographer that I have been able to draw on such a rich fund of

source material for this book. And it is with considerable pleasure that I see this 'invisible man' making a small mark on history.

Annette Kuhn
January 2002

1

Family Secrets:
an Introduction

Although we take stories of childhood and family literally, I think our recourse to this past is a way of reaching for myth, for the story that is deep enough to express the profound feelings we have in the present.

Most of us imagine the family as a place of safety, closeness, intimacy; a place where we can comfortably belong and be accepted just as we are. If we think of family ties as given, not chosen, they have this much at least in common with our other attachments: nation, race, class, gender. And yet we know quite well that in real life matters are rarely quite so simple. Just as for many family life is precarious, so these other allegiances are as often as not uncertain and mutable. And if it is we who, by imagining them, bring into being our 'imagined communities', we are undoubtedly formed by them, too. For in a way they actually are 'out there', they do pre-exist us. Disputing the givenness of social categories like class, race, gender identity and sexual preference confers no exemption from the necessity of negotiating their social meanings in daily life. For example, while fully aware that femininity is a fabrication, as far as

1

the world is concerned – and indeed as far as I, too, am concerned – I am still a woman, and live with the very real consequences of a particular gender label. So it is with the identity conferred by family.

A family without secrets is rare indeed. People who live in families make every effort to keep certain things concealed from the rest of the world, and at times from each other as well. Things will be lied about, or simply never mentioned. Sometimes family secrets are so deeply buried that they elude the conscious awareness even of those most closely involved. From the involuntary amnesias of repression to the wilful forgetting of matters it might be less than convenient to recall, secrets inhabit the borderlands of memory. Secrets, in fact, are a necessary condition of the stories we are prompted by memory to tell about our lives.

Telling stories about the past, our past, is a key moment in the making of our selves. To the extent that memory provides their raw material, such narratives of identity are shaped as much by what is left out of the account – whether forgotten or repressed – as by what is actually told. Secrets haunt our memory-stories, giving them pattern and shape. Family secrets are the other side of the family's public face, of the stories families tell themselves, and the world, about themselves. Characters and happenings that do not slot neatly into the flow of the family narrative are ruthlessly edited out.

But exactly what sort of family is at stake in this book, *Family Secrets*? A kinship group, a real-life one, the author's own, perhaps? Or the family as an *idea*, an abstraction that provides the model for so many forms of belonging? And what sort of secrets, for that matter? Each term – family, secrets – has so many meanings. If

family secrets are to be disclosed, does this suggest some personal revelation, confession even? Or it is a question more of what goes into the activity of bringing the secrets to light? Am I making public what I have consciously known but never before revealed, or am I seeking knowledge that is as new to me as it is to you?

The family secrets are indeed mine – in a manner of speaking; and like all such things, they have roots in the past and reverberations in the present. None of which can be understood until the memories behind the secrets are brought to light and looked at closely. This calls for a certain amount of delving into the past, and for preparedness to meet the unexpected. What is required is an active and directed work of memory.

Since my family secrets are no doubt shaped by the same kinds of amnesias and repressions as other people's, their substance will very likely seem familiar, commonplace even. Few of my secrets are likely to be particularly out of the ordinary. But if my family secrets are neither unique nor special, that is precisely the point. Neither, though they take an individual life as their starting point, are the stories that I have to tell autobiographical in any conventional sense of the word. I offer no life story organised as a linear narrative with a beginning, a middle and an end, in that order. Nor is the present the goal towards which my stories are inexorably directed. The present figures rather differently, in fact: indeed the memory work that makes the telling of my stories possible is in many ways more important, and certainly of greater practical use in the present, than their actual content.

If pressed to slot these pieces of memory work, my memory texts, into some sort of category, I would hazard first of all that they tread a line between cultural criticism and cultural production; or

3

rather that they try to span the gulf between those who comment on the productions of culture and those who actually do the producing. As such, they are driven by two sets of concerns. The first has to do with the ways memory shapes the stories we tell, in the present, about the past – especially stories about our own lives. The second has to do with what it is that makes us remember: the prompts, the pretexts, of memory; the reminders of the past that remain in the present. If *Family Secrets* has a prime objective, it is to unravel the connections between memory, its traces, and the stories we tell about the past, especially – though not exclusively – about the past of living memory.

The past is gone for ever. We cannot return to it, nor can we reclaim it now as it was. But that does not mean it is lost to us. The past is like the scene of a crime: if the deed itself is irrecoverable, its traces may still remain. From these traces, markers that point towards a past presence, to something that has happened in this place, a (re)construction, if not a simulacrum, of the event can be pieced together. Memory work has a great deal in common with forms of inquiry which – like detective work and archaeology, say – involve working backwards – searching for clues, deciphering signs and traces, making deductions, patching together reconstructions out of fragments of evidence.

The clues that form the starting point of my excursions into memory work are traces of my own past: for the most part, images and memories associated with them. The images are both 'private' (family photographs) and 'public' (films, news photographs, a painting): though, as far as memory at least is concerned, private and public turn out in practice less readily separable than conventional wisdom would have us believe. Each of the essays that follow is a

4

case history in its own right: an image, images, or memories are at the centre of a radiating web of associations, reflections and inter-pretations. But if the memories are one individual's, their associations extend far beyond the personal. They spread into an extended network of meanings that bring together the personal with the familial, the cultural, the economic, the social, the histor-ical. Memory work makes it possible to explore connections between 'public' historical events, structures of feeling, family dramas, relations of class, national identity and gender, and 'per-sonal' memory. In these case histories outer and inner, social and personal, historical and psychical coalesce; and the web of inter-connections that binds them together is made visible.

In working on these case histories, I made a number of discov-eries about how remembering works and how it is expressed and produced through 'memory texts', cultural productions across a range of media, which like the fruits of my own memory work, are in effect secondary revisions of the source materials of memory. Memory texts also appear to be a cultural phenomenon, a genre even, in their own right. I observed the unfolding in memory texts of connections between memory and the past, memory and time, memory and place, memory and experience, memory and images, memory and the Unconscious. Above all I have seen how, in all memory texts, personal and collective remembering emerge again and again as continuous with one another, and the interconnections are exposed and examined in each of the essays which follow.

Thus while the order in which the essays appear – starting with readings of my own photographs and moving towards more public types of memory text and less obviously 'personal' readings – enacts a trajectory from personal to collective, from 'home',

perhaps, to 'nation', this is by no means to imply that these are to be regarded as distinct from one another. On the contrary: if my discoveries about memory call to mind the old liberationist and feminist slogan 'The personal is political', they offer a far more profound understanding of that statement than any sloganising would admit. Clearly, if in a way my memories belong to me, I am certainly not their sole owner. All memory texts – and that includes the essays in this book – constantly call to mind the collective nature of the activity of remembering.

In unearthing some of 'my' family secrets, I have learned in the most practical and immediate way that, with the proper motivation, memory work, especially when it draws on the readily available resource of the family album, is easy to do, offers methodological rigour, and is fruitful in countless, often unexpected, ways. As the veils of forgetfulness are drawn aside, layer upon layer of meaning and association peel away; revealing not ultimate truth, but greater knowledge. Memory work has about it the quality of pursuing the enigma in a mystery novel that turns on characters' remembering things buried deep in their past and long forgotten: except that in a novel there is always an ending, and usually a resolution. Memory work, on the other hand, is potentially interminable: at every turn, as further questions are raised, there is always something else to look into. Every one of the case histories in this book could be pursued further.

My discoveries are not all congenial, however. I was made quite forcibly aware of the murderous hostility towards the mother implicit in the standpoint which I recognise (and indeed celebrate) as my own, that of the questioning, challenging daughter; of the losses, as well as the gains, of growing out of infancy, learning to

speak and becoming an entity, a self, separate from a world that has hitherto met every need; of the narrowing of possibilities as schooling trammels the free-ranging imaginings of childhood into the confines of curricular knowledge; of an uprooting, a rejection of a birthright, the price of trying on a new social class identity; of the amnesias, the repressions, that make possible a sense of belonging, fragile and ambivalent as it might be, to class, family, nation, and to a dominant ethnic group. But it is not, surely, to be concluded from this that the past is better left undisturbed. These 'shadows' are a proper part of life, and must not – indeed they cannot – be split off from what is more agreeable or acceptable, to be simply hidden from sight. For the repressed will always return, and more often than not in some infinitely more ugly guise. Bringing the secrets and the shadows into the open allows the deeper meanings of the family drama's mythic aspects to be reflected upon, confronted and understood at all levels. This in turn helps in coming to terms with the feelings of the present, and so in living more fully in the present.

Memory work requires the most minimal resources and the very simplest procedures. Making do with what is to hand – its raw materials are almost universally available – is the hallmark of memory work's pragmatism and democracy. Anyone who has a family photograph that exerts an enigmatic fascination or arouses an inexplicable depth of emotion could find memory work rewarding. In working on my own memory materials, and on photographs especially, I have drawn freely on the very useful protocols set out by Rosy Martin and Jo Spence for their phototherapy and family album work. As a first step towards eliciting as wide a range of

associations as might be appropriate in the circumstances, these help the memory-work practitioner separate out a photograph's various contexts:

1. Consider the human subject(s) of the photograph. Start with a simple description, and then move into an account in which you take up the position of the subject. In this part of the exercise, it is helpful to use the third person ('she', rather than 'I', for instance). To bring out the feelings associated with the photograph, you may visualise yourself as the subject as she was at that moment, in the picture: this can be done in turn with all of the photograph's human subjects, if there is more than one, and even with animals and inanimate objects in the picture.

2. Consider the picture's context of production. Where, when, how, by whom and why was the photograph taken?

3. Consider the context in which an image of this sort would have been made. What photographic technologies were used? What are the aesthetics of the image? Does it conform with certain photographic conventions?

4. Consider the photograph's currency in its context or contexts of reception. Who or what was the photograph made for? Who has it now, and where is it kept? Who saw it then, and who sees it now?

Memories and associations generated in the course of this exercise can stand on their own as discoveries, or may feed into reflective, interpretive or analytical phases of memory work. They also help the practitioner move beyond a purely personal response and towards a consideration of the photograph's cultural and historical

embeddedness, its broader meanings, and – very importantly – the responses it generates. All this calls to mind John Berger's contention that the incorporation of photography into social and political memory calls for a radical approach to reading, as much as to making, photographs: 'A radial system has to be constructed around the photograph,' says Berger, 'so that it may be seen in terms which are simultaneously personal, political, economic, dramatic, everyday and historic'.

As with photographs, so with other memory prompts: the democratic quality of memory work makes it a powerful practical instrument of 'conscientisation': the awakening of critical consciousness, through their own activities of reflection and learning, among those who lack power; and the development of a critical and questioning attitude towards their own lives and the lives of those around them. As a practice that begins with the practitioner's own material – her memories, her photographs – memory work offers a route to a critical consciousness that embraces the heart as well as the intellect, one that resonates, in feeling and thinking ways, across the individual and the collective, the personal and the political.

Memory work is a method and a practice of unearthing and making public untold stories, stories of 'lives lived out on the borderlands, lives for which the central interpretive devices of the culture don't quite work'. These are the lives of those whose ways of knowing and ways of seeing the world are rarely acknowledged, let alone celebrated, in the expressions of a hegemonic culture. Practitioners of memory work may be conscientised simply through learning that they do indeed have stories to tell, and that their stories have value and significance in the wider world. At the

same time, as an aid to radicalised remembering, memory work can create new understandings of both past and present, while yet refusing a nostalgia that embalms the past in a perfect, irretrievable, moment. Engaging as it does the psychic and the social, memory work bridges the divide between inner and outer worlds. It demonstrates that political action need not be undertaken at the cost of the inner life, nor that attention to matters of the psyche necessarily entails a retreat from the world of collective action.

The case studies in *Family Secrets* are capable of being read in a number of ways: for the stories they tell about a particular life, stories which will perhaps speak with a peculiar urgency to readers in whom they elicit recognition of a shared history; as a contribution towards understanding how memory works culturally; for what they offer more generally to theories of culture and methods of cultural analysis; and perhaps most important of all, as a recipe, a toolkit, even an inspiration, for the reader's own memory work.

2

'She'll Always Be Your Little Girl . . .'

This is a story about a photograph; or rather, several stories of a sort that could be told about many photographs, yours as well as mine.

The six-year-old girl in the picture over the page is seated in a fireside chair in the sitting room of the flat in Chiswick, London, where she lives with her parents, Harry and Betty. It is the early 1950s. Perched on the child's hand, apparently claiming her entire attention, is her pet budgerigar, Greeny. It might be a winter's evening, for the curtains are drawn and the child is dressed in hand-knitted jumper and cardigan, and woollen skirt.

Much, but not all, of this the reader may observe for herself, though the details of time and place are not in the picture: these are supplied from elsewhere, let us say from a store of childhood memories which might well be anybody's, for they are ordinary enough. The description of the photograph could be read as the scene-setting for some subsequent action: one of those plays, perhaps, where the protagonists (already we have four, which ought to be enough) will in a moment animate themselves into the toils of

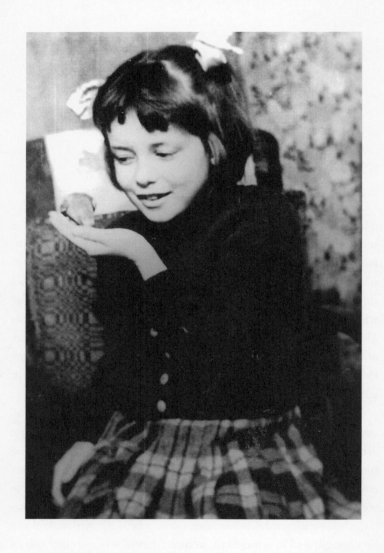

some quite humdrum, yet possibly oddly riveting, family melo-
drama.

All this is true, up to a point. Photographs are evidence, after all.
Not that they are to be taken only at face value, nor that they
mirror the real, nor even that a photograph offers any self-evident
relationship between itself and what it shows. Simply that a pho-
tograph can be material for interpretation – evidence in that sense:
to be solved, like a riddle; read and decoded, like clues left behind
at the scene of a crime. Evidence of this sort, though, can conceal,
even as it purports to reveal, what it is evidence of. A photograph
can certainly throw you off the scent. You will get nowhere, for
instance, by taking a magnifying glass to it to get a closer look: you
will see only patches of light and dark, an unreadable mesh of
grains. The image yields nothing to that sort of scrutiny, it simply
disappears.

To show what it is evidence of, a photograph must always point
you away from itself. Family photographs are supposed to show not
so much that we were once there, as how we once were: to evoke
memories that might have little or nothing to do with what is actu-
ally in the picture. The photograph is a prop, a prompt, a pre-text:
it sets the scene for recollection. But if a photograph is somewhat
contingent in the process of memory-production, what is the status
of the memories actually produced?

Prompted by this photograph, I might recall, say, that the budgie
was a gift from Harry to his little girl, Annette; that underneath two
layers of knitted wool, the child is probably wearing a liberty
bodice; that the room in which the photo was taken was referred to
not as the sitting room but as the lounge, or perhaps occasionally as
the drawing room. Make what you will of these bits of information,

13

true or not. What you make of them will be guided by certain knowledges, though: of childrearing practices in the 1950s, of fashions in underwear, of the English class system, amongst other things.

What I am saying is: memories evoked by a photo do not simply spring out of the image itself, but are generated in a network, an intertext, of discourses that shift between past and present, spectator and image, and between all these and cultural contexts, historical moments. In this network, the image itself figures largely as a trace, a clue: necessary, but not sufficient, to the activity of meaning making; always pointing somewhere else. Cultural theory tells us there is little that is really personal or private about either family photographs or the memories they evoke: they can mean only culturally. But the fact that we experience our memories as peculiarly our own sets up a tension between the 'personal' moment of memory and the social moment of making memory, or memorising; and indicates that the processes of making meaning and making memories are characterised by a certain fluidity. Meanings and memories may change with time, be mutually contradictory, may even be an occasion for, or an expression of, conflict.

On the back of this photograph is written, in my mother's hand: 'Just back from Bournemouth (Convelescent) [*sic*]'. In my own handwriting 'Bournemouth' has been crossed out and replaced with 'Broadstairs', and a note added: 'but I suspect the photo is earlier than this'.

If, as this suggests, a photograph can be the site of conflicting memories, whose memory is to prevail in the family archive? This little dispute between a mother and a daughter points not only to

the contingency of memories not attached to, but occasioned by, an image, but also to a scenario of power relations within the family itself. My mother's inscription may be read as a bid to anchor the meaning of a wayward image. But her meaning at some point conflicted with my own reading of the photograph and also irritated me enough to provoke a (somewhat restrained) retort. As it turns out, my mother and I might well both have been 'off' in our memories, but in a way this doesn't matter. The disagreement is symptomatic in itself, in that it foregrounds a mother–daughter relationship to the exclusion of something else. The photograph and the inscriptions point to this 'something else' only in what they leave out. What happens, then, if we take absences, silences, as evidence?

The absent presence in this little drama of remembering is my father. He is not in the picture, you cannot see him. Nor can you see my mother, except insofar as you have been told that she sought to fix the meaning of the image in a particular way, to a particular end. In another sense, however, my father is very much 'in' the picture; so much so that my mother's intervention might be read as a bid to exorcise a presence that disturbed her. The child in the photograph is absorbed with her pet bird, a gift from her father, who also took the picture. The relay of looks – father/daughter/father's gift to daughter – has a trajectory and an endpoint that miss the mother entirely. The picture has nothing to do with her.

Here is another story: about taking a photograph indoors at night in the 1950s, on (probably slow) black-and-white film in a 35mm camera. My father knew how to do this and get good

results because photography was his job: he was working at the time as, if you like, an itinerant family photographer; canvassing work by knocking on likely-looking (that is to say, 'respectable' working-class) doors, taking pictures of children in the parents' homes or gardens, and developing and printing them in a rented darkroom. This must have been the last moment of an era when, if people wanted something better than a blurred snapshot from a Box Brownie, they would still routinely commission photographs of their children. The photo of me, no doubt, is the sort of picture Harry Kuhn might have made for any one of his clients.

Stylistically speaking, that is: for at this level the picture eschews the conventions of the family photograph to key, perhaps, into professional codes of studio portraiture; or into the cute-kiddie-with-pet subgenre of amateur photography. The peculiar context of this picture's production lends it very different cultural meanings, however, and imbues it (for me) with a kind and an intensity of feeling a professional or hobbyist piece of work would scarcely evoke. In this image, Harry's professional, his worldly, achievements are brought home, into a space where such achievements were contested, or at best held as irrelevant. In this photograph, my father puts himself there, staking a claim: not just to his own skills, to respect, to autonomy; but to the child herself. In this picture, then, Harry makes the child his own daughter. Later on, my mother would insist that this was not so, that Harry Kuhn was not my father.

Thus can a simple photograph figure in, and its showing set the scene for the telling of, a family drama – each of whose protagonists might tell a different tale, or change their own story at every

[handwritten margin note: Professional Home photographer]

retelling. What I am telling you – 'my own story' – about this picture is itself changeable. In each re-enactment, each re-staging of this family drama, details get added and dropped, the story fleshes out, new connections are made, emotional tones – puzzlement, anger, sadness – fluctuate.

Take my mother's caption to the picture – I don't know when it was written – and my own alteration and footnote, added because I believed she had misremembered a key event of my childhood. At eight years old (two years, that is, after this picture was taken), I was sent off to a convalescent home in Broadstairs, Kent, after a bad bout of pneumonia and a spell in hospital. The adult Annette took the apparent errors of time and place in her mother's caption (by no means an isolated instance) as yet another manifestation of obsessive (and usually 'bad') remembering; as an attempt by her mother to force others' memories into line with her own, however off-the-wall these might be. A capricious piece of power-play, if you like, but – given the transparent inaccuracy of the details – easily enough seen through.

Another, and more disturbing, reading of my mother's inscription is available, however: possibly the biographical details are correct after all, but refer not to me, the ostensible subject of the picture, but to my mother herself. Around the time the photograph was taken, she had suffered an injury at her job as a bus conductor, and been sent by London Transport to convalesce at the seaside. Is this perhaps the event to which the caption refers? If so, my mother is pinning the moment of a photograph of her daughter to an event in her own life.

In the first reading, my mother writes herself into the picture by claiming the right to define the memories evoked by it; and by

omission and commission negates my father's involvement in both the photograph and the family. In the second reading, my own involvement as well as my father's is negated, as the caption constitutes a central place for the writer herself in a scenario from which she is so clearly excluded. My mother has grabbed the starring role, setting herself up as both enunciator of, and main character in, the family drama.

The intensity of feeling attaching to these stories greatly exceeds the overt content of the tales of dissension and deception in the family I seem to have unearthed: utter rage at my mother's egomaniac powermongering; sadness at the nullification of my father's stake in the picture/the family; joy in the possibility of remembering his nurturing me; grief over his loss of power and over my loss of him, for I was soon to become in effect my mother's property. My use of this photograph as a piece of evidence, a clue – as material for interpretation – is an attempt, then, to instate and enact if not exactly a father's, then certainly a daughter's, version of a family drama.

A photograph bearing a huge burden of meaning and of feeling, this one – to use Roland Barthes's term – *pierces* me. It seems to utter a truth that goes beyond the *studium*, the evidential, however intricately coded. My desire is that the little girl in the picture be the child as she is looked at, as she is seen, by her father. A friend who has not heard these stories says about the picture: there is a poignancy about her absorption with her pet; she looks lovable with her floppy hair ribbons and warm woollen clothing. Perhaps Harry Kuhn, in giving the child the gift of a living creature, and even more so in the act of making this photograph, affirms not merely a dubious paternity, but also that he loves this child. This

photograph, I want to believe, in speaking a relation that excludes her, resists – perhaps finally transcends – my mother's attempt to colonise its meaning.

The stories, the memories, shift. There is a struggle over who is to have the last word – me; my father, the idealised father who figures in my desire; my mother, the monstrous mother of my fantasy. There is unlikely ever to be a last word, as the struggle over the past continues in the present. The struggle is now, the past is made in the present. Family photographs may affect to show us our past, but what we do with them – how we use them – is really about today, not yesterday. These traces of our former lives are pressed into service in a never-ending process of making, re-making, making sense of, our selves – now. There can be no last word about my photograph, about any photograph.

Here, then, is one more story: about a family album; about the kinds of tales (and the kinds of families) family albums construct; and about how my photograph was put to use once upon a time, and still survives to be used today, again and again.

Family photographs are quite often deployed – shown, talked about – in series: pictures get displayed one after another, their selection and ordering as meaningful as the pictures themselves. The whole, the series, constructs a family story in some respects like a classical narrative: linear, chronological; though its cyclical repetitions of climactic moments – births, christenings, weddings, holidays (if not in my culture deaths) – is more characteristic of the open-ended narrative form of the soap opera than of the closure of classical narrative. In the process of using – producing, selecting, ordering, displaying – photographs, the family is actually in the process of making itself.

The family album is one moment in the cultural construction of family; and it is no coincidence that the conventions of the family album – what goes in and how it is arranged – are, culturally speaking, rather circumscribed. However, if the family album produces the family, produces particular forms of family in particular ways, there is always room for manoeuvre within this, as within any other, genre. People will make use of the 'rules' of the family album in their own ways.

The one and only family album in my immediate family is a case in point. It was made by me at the age of eight, when I collected together some snapshots with a few studio portraits and some of my father's relatively professional efforts, stuck them in an album (whose cover, significantly, sports the legend: 'Memory Lane'), and captioned them. Even at such an early age, I obviously knew all about the proper conventions of the family album: photos of myself, my parents, and a few of other relatives and of friends are all set out in chronological order – starting with a picture of me at six months old in the classic tummy-on-the-rug pose.

The eight-year-old Annette clearly 'knew', too, what a family album is for. If she was putting together her 'own' history, this sought to be a history of a family as much as of an individual; or rather, of an individual in a family. The history constructed is also an expression of a lack, and of a desire to put things right. What is being made, made up for, by the work of the album is the 'real' family that the child's parents could not make: this particular family story starts not with a wedding, but with a baby. The album's project is to position that baby, that child, the maker, within a family: to provide itself/herself with a family. Giving herself the central role

in the story told by the album, the child also gives herself a family: not only positioning herself within a family, but bringing it into being – authoring it, parenting it.

Now, as I tell this story, I can set an interpretation of an eight-year-old girl's preoccupation with photographs alongside a reading, today, of a picture that figures in the collection she put together – a portrait of the same child, a couple of years younger, raptly involved with the pet bird perched in her hand. My mother's reading of that portrait is at odds not only with my present understanding(s) of it, but also with the little girl's account, in the photograph album she made, of herself and of the family she wanted.

Whilst my 'Memory Lane' album contains a number of photographs of me as a baby and a toddler with my father, there are few early pictures of me with my mother. There is no way of knowing whether this is because no pictures of me with my mother were actually made, or whether it is because certain images were selected for the album in preference over others. Whatever the explanation, the outcome is that, in a child's first years, a father–daughter relationship is foregrounded at the expense of that between a mother and daughter. Just as Harry's photograph of Annette excludes Betty, so too does the family album marginalise her. Or at least seems to try to: my mother does make more frequent appearances in its later pages, though still not often with me. Both these observations speak of conflict: between my father and my mother over me; between my mother and me over the 'truth' of the past. In all of these struggles, my project was to make myself into my father's daughter. My mother's project – in an ironic twist of the Oedipal triangle – was to cast herself as my only begetter. Not, however,

with complete success: had her story carried the day, you would not now be reading mine.

My stories are made in a tension between past and present. I have said that a child's making a family album was an expression of, and an attempt to come to terms with, fears and desires; to deal with a knowledge that could not be spoken. These silences, these repressions, are written into the album, into the process of its making, and into actual photographs. All the evidence points in the same direction: something in the family was not right, conflicts were afoot: conflicts a little girl could not really understand, but at some level knew about and wanted to resolve. Solving the puzzle and acknowledging *in the present* the effects *in the past* of a disturbance in the family must be the necessary conditions of a retelling of the family story in its desired 'proper' order.

As clues are scrutinised and pieces fitted together, a coherent story starts to emerge from the seeming contingency and chaos of a past hinted at by these fragments – a photograph, a photograph album, some memories. A coherent story not only absorbs the listener, but – being a moment in the production of self – satisfies the teller as well, for the moment at least.

Family photographs are about memory and memories: that is, they are about stories of a past, shared (both stories and past) by a group of people that in the moment of sharing produces itself as a family. But family photography is an industry, too, and the makers of the various paraphernalia of family photography – cameras, film, processing, albums to keep the pictures in – all have a stake in our memories. The memories promised by the family photography industry are characterised by pleasure and held-off

closure – happy beginnings, happy middles, and no endings to all the family stories. ('She'll always be your little girl because you took a picture', ran the slogan in a 1955 advertisement for Kodak film.) In the way of these things, the promises point towards the future: our memories, our stories *will* be. They *will* be shared, they *will* be happy – the tone of the seduction is quite imperious. With the right equipment to hand, we will make our own memories, capture all those moments we will some day want to treasure, call to mind, tell stories about.

The promise is of a brighter past in the future, if we only seize the chance today to consume the raw materials of our tomorrow's memories. This past-in-the-future, this nostalgia-in-prospect, always hooks into, seeks to produce, desires hinging on a particular kind of story – a family story with its own forms of plenitude. The subject position publicly offered is, if not quite personal (consumption is, after all, a social activity), always in the 'private' realm of household and family. All this is familiar enough to the cultural commentator. But the discourses of consumerism form just one part of a bigger picture, one moment in a longer – and probably more interesting – story about the uses of family photography.

Desire is an odd thing. If it can be called upon, even if it can be harnessed to consumption, it can also be unruly and many-sided. It can run behind, or ahead of, the better past tomorrow promised by the family photography industry; it can run somewhere else entirely; it can, perhaps, not run at all. When we look at how family photographs may be used – at what people can do with them once they have them – past and present and the tension between them insert themselves into an equation weighted a little too much

towards a certain sort of future. This can stir things up, confuse matters – possibly productively. Just as there is more than one way of making photographs, so there is more than one way of making use of them. If, however commonplace, my pictures and my stories are not everybody's, my uses of the one and my methods of arriving at the other, could very well be.

3

The Little Girl Wants to
be Heard

Language brings us together; it pulls its apart; it makes possible our fictions of the past, and our imaginings of the future.

After a hard struggle towards understand what language is, what it is for, a congenitally deaf child speaks her first words at the age of seven, first of all naming her mother ('Mummy'), then herself ('Mandy').

Mandy is a character in a film, the pivotal figure of a family drama. Mandy's parents disagree over how their daughter should be brought up: the father favours keeping the child at home, the mother wants to send her to a special school. The conflict threatens to split the couple as Mandy, taken away by her mother to attend a school for the deaf, embarks on her own lonely struggles with communication, with learning to live with others outside her own family. Various obstacles along the path serve to convince Mandy's father that he has been right all along; Mandy should stay at home. In the end, though, the mother's risk is rewarded, and the rift in the family healed, when Mandy at last speaks her own name.

It is 1952: Mandy's story unfolds on a cinema screen in West London, watched by a little girl of about Mandy's age who has been brought along by her mother to see this picture everyone is talking about. The little girl sees only Mandy: her heart goes out to this deaf-mute child who, with her pigtails, woollen pleated skirt, muffler and gloves, could so easily be herself. She desperately wants Mandy to triumph. At the end of the film, showing the world she can now 'listen', can understand ('Lend us your ball,' shouts a boy among a group of children at play. Mandy offers it to him with a smile. 'What's your name?' he asks), Mandy makes the supreme effort to utter her name. With an equally intense effort of concentration, the girl in the audience wills the sound to come from those silently mouthing lips; inwardly, urgently, speaks the name for her; feels such release when Mandy at last, in flat unin-flected tones, manages to achieve the two syllables; holds her breath once more in the moment before the boy responds (will he understand these strange sounds? will he jeer?); weeps with joy as Mandy runs off after the other children, spontaneously joining in their game.

Seeing her tears, seeing how affected she has been by Mandy, did the other little girl's mother try to reassure her daughter ('It's only a story')? Even if she understood this, the child had certainly been moved – changed – by this film: most particularly by Mandy's long-awaited uttering of her own name. She was to find those sounds and images, and the feelings evoked by them, insistently memorable, held in the store of remembrance like a compelling dream, a vision, outside and beyond the everyday.

The little girl in the audience is, of course, an earlier version of the present writer.

*

1980: When, some twenty-eight years on, I was reintroduced to *Mandy*, it was in the context of a graduate seminar on British cinema that I was teaching at a university in the USA. Already, a couple of years earlier, I had been reminded of the film's existence – now from the standpoint of the scholar – experiencing that pleasant and nervous shock of recognition that comes when, having gone up in the world, and feeling rather detached from the person one once was, one sees a half-forgotten former love on the other side of the street. Should one say hello, or just let the past be?

Mandy, I had learned, was one of Ealing Studios' 'serious' post-war films. It was directed by Alexander Mackendrick, with whose work at Ealing, especially *The Man in the White Suit* (a 1951 comedy starring Alec Guinness and briefly featuring Mandy Miller, the child actress who would later play the role of Mandy), I was already familiar. But my recognition of *Mandy* as the film which had figured so significantly in my childhood was prompted not by the conventional identifiers – director, studio, year of release – but by the emotional resonance of its title, the name of Mandy.

I had not yet ventured to see the film again. Could I risk the potential disillusion of fresh acquaintance with an object so emotionally charged – I was no longer the same person as that little girl, after all – or would it be wiser to turn aside, leaving childhood memories intact? In the end, curiosity won: I took the opportunity offered by the seminar. But as it transpired, in reviewing the film in a culturally alien and, in scholarly and professional terms, rather demanding context – one which seemed to call for an intellectual, and to eschew any affective, response – I did at this point succeed in defending my childhood vision.

All the same, *Mandy* did respond well to the structuralist/semiotic approach adopted in the seminar, which proved both pedagogically rewarding and analytically productive. Among its more significant findings was the observation that, confounding conventional wisdom about the unobtrusive style of the Ealing product, some parts of *Mandy* are marked by an extraordinary degree of expressivity of sound and image: low-key lighting, marked camera angles, big distorted closeups, deep focus cinematography, narratively unmotivated mobile framing, distortions – even momentary absences – of sound.

The early scenes of the film, for example, which narrate the discovery by Harry and Christine Garland of their daughter's deafness, produce a 'disturbed' mise-en-scene which appears to express the parents' unspoken anxieties. The Garlands' faces are

crossed by shadow, or their bodies are silhouetted against a backlight; and we are introduced to a shot which will become a *leitmotiv*: a point-of-view angle on the back of a character's head, suggesting not-hearing. At this point, the head is Mandy's; later, 'hearing' characters – Harry in particular – are shown, through this same shot, as incapable of listening, of hearing the truth.

'Melodramatic' codes – of lighting and deep focus, in particular – also mark the mise-en-scene of the large house belonging to Harry's parents, to which the couple and their child move so that Mandy can have a live-in governess. And distorted closeups and expressivity of sound are associated with Mandy's moments of crisis: from an episode early in the film when she runs into the road after her dog, straight into the path of an oncoming

lorry – which of course she has not beard – through to the moment in the last scene when she at last speaks her own name.

Other parts of *Mandy* do, though, retain some of the qualities of naturalistic realism more familiarly associated with Ealing films. These are particularly apparent in scenes dealing with the education of the deaf, some of which have an almost documentary quality – uniform lighting, greater distance than elsewhere between camera and object, minimal – and always motivated – mobile framing. (Parts of the film were in fact shot in a school for the deaf.) And yet, certain features of the setting in which the children are taught – the gloomy and cavernous Victorian gothic of the school's entrance hall and corridors, especially – echo the spaces associated with the film's more melodramatic moments. Here, and also at the points when Mandy's crisis erupts into the documentary discourse, the film's melodramatic qualities pervade its social realism, rather than vice versa.

Formal features of the text associated with the melodramatic on the one hand and the naturalistic on the other, and the tension between them, point towards a certain symptomatic, even ideological, reading of the film. At the levels of both narrative and mise-en-scene, for example, the world of the family in *Mandy* is constructed as repressive and confining; while the question of communication and its lack inhabits the visual and auditory space of the film at several levels, some of them more immediately apparent than others.

The nuclear family home – the Garlands' flat – is full of shadows and seems isolated from the outside world; the extended family home – the grandparents' house – has an iron-barred front entrance and an elegant facade that conceals decay within and a wasteland to the rear; while Mandy's troubles are due as much to her inability

to relate to people outside her family as to her disability. In many respects, as a symptomatic reading reveals, *Mandy* foreshadows the family melodramas, better known today, that were to issue from Hollywood later in the 1950s.

For a seminar in film studies, this sort of reading of *Mandy* obviously yields rich rewards. But the method of film analysis which generates it – one directed primarily at textual systematicity – made it difficult for the class to address other key features of the film. What, for example, can text-based work of this kind reveal about the relationship between the film's story and settings (the decaying splendour of the grandparents' house, the waste ground that lies behind it, the Victorian gloom of Mandy's school) and the historical context of its production and reception? And what of *affect*, what of the emotional response invited by a film which made a frank appeal to its audiences' hearts? ('She'll find a home in every heart; she'll reach the heart of every home', proclaimed the film's poster.)

Significantly, a reading of *Mandy* which emphasises the film's qualities as melodrama, while usefully directing attention to the Garlands' relationship and its significance, and placing the character Mandy herself within the frame of family relations, greatly underplays the importance of Mandy's own story – of her quest to break out of isolation and communicate with others. It cannot see, precisely because it is not looking for, Mandy's struggles to hear, listen, speak, and enter society. At first sight, given that the film is so patently 'about' Mandy – the title is explicit enough, after all – this omission is not easy to understand.

And yet it is certainly beyond doubt that excluding Mandy's story from the seminar allowed me, as teacher, to defend my

childhood memories of the film – memories which had in fact constructed it precisely and simply as that: Mandy's story. All the rest – the conflict between Harry and Christine, the Searle–Christine subplot – I had taken on board only as an adult spectator. My memory of Mandy's story, though, not only remained extremely intense; it also took the form of quite specific images and sounds – precisely those associated with Mandy's crisis moments. All of these remembered sounds and images were, and still are, highly emotionally charged.

It is the mid 1980s: Annette is in a Soho wine bar with a woman friend, also a film critic. Somehow, the topic of *Mandy* enters the conversation, and the two women chat for a while about the film, in the way people who enjoy cinema, and enjoy ideas about cinema, do. Suddenly, Annette bursts into tears.

If the moment passed in ruefully understanding laughter, it was certainly an odd one. The tears had come, unbidden and insistent, from some part of Annette that was decisively not the film scholar, nor even the cinephile. The grownups' conversation had been interrupted by something inappropriate and other – a child's response, troubling and impossible to ignore. The little Annette had at last successfully waylaid the adult, forcing some difficult questions on to the agenda.

How does a film scholar deal with a child's response to a film? Must such a response be excluded from the adults' conversation, from the intellectual, the analytical? What exactly is the difference between these responses, the child's and the adult's? Are they irreconcilable, or can they be brought together in our attempts to understand how films work, how they engage our feelings and our

fantasies? Does the naive, the untutored, the everyday response have anything to offer the professional, the academic, the intellectual one?

For a film theorist, these are uncomfortable questions. Not only do they bring to centre stage some relatively familiar – and enduringly difficult – problems concerning the reception of films; they also complicate these matters yet further by adding the elusive dimensions of feeling and memory. How can film theory address itself to the emotions films evoke, to the ways in which these emotions enter into people's fictions of the past, their own past? Any feeling response to a film – and indeed recollections of such a response even more so – threatens to elude our attempts to explain or intellectualise, not because the latter are somehow inadequate in the face of the former but because each category (memory/feeling as against explanation/analysis) seems to inhabit an altogether distinct register.

Emotion and memory bring into play a category with which film theory – and cultural theory more generally – are ill equipped to deal: experience. Indeed they have been wary of making any attempt to tackle it, and quite rightly so. For experience is not infrequently played as the trump card of authenticity, the last word of personal truth, forestalling all further discussion, let alone analysis. Nevertheless, experience is undeniably a key category of everyday knowledge, structuring people's lives in important ways. So, just as I know perfectly well that the whole idea is a fiction and a lure, part of me also 'knows' that my experience – my memories, my feelings – are important because these things make me what I am, make me different from everyone else. Must they be consigned to a compartment separate from the part of me that thinks and

analyses? Can the idea of experience not be taken on board – if with a degree of caution – by cultural theory, rather than being simply evaded or, worse, consigned to the domain of sentimentality and nostalgia?

The little girl wants to be heard, and children ask the hardest questions of all. The adult Annette cannot pretend to deliver all, or indeed perhaps any, of the answers to the big questions that the child's insistent interruptions pose for cultural theory and for film theory. But she can at least *listen* to what the little Annette has to say. This would mean bringing the child's response to *Mandy* into the light of day, holding on to it, and using it as material for interpretation. The film scholar does not thus give herself over to the child's demands, nor relinquish her analytic stance: rather, she sharpens and refines her perceptions, expands the frame of her competence.

Such a process will immediately shift attention to Mandy's story. It forces me to look, in a particular way, at the specifics of the story's address, at how it speaks to the child in both the child and the adult. It also lets me look at questions of feeling and memory in the context of the ways in which the film both speaks, and also draws me into, its historical moment. It even suggests some fresh ways of reading films and doing film theory.

Mandy's predicament is central to the direction of the film's narrative: a key problem, perhaps *the* key problem, set up for the story to deal with is her deafness, first discovered when she is around two years old. At six, Mandy is still unable to communicate, either with adults or with other children, and this makes her susceptible to violent, frustrated rages. She is taken to the Bishop David School for the Deaf, where on her first day she makes her

first real contact with another child. Initially, however, she cannot settle in as a boarder, refuses to play with the other children, behaves uncontrollably. But on becoming a day pupil she starts making progress, learning to produce sounds. With extra coaching, she soon speaks her first word: 'Mummy'. She suffers a setback on being taken away from the school; but triumphs in the end by going out to meet a group of children playing behind her house, telling them her name, and joining in their game.

This version of the story traces the various stages of Mandy's entry into language, figured as a movement from isolation towards communication and sociability; from the nuclear family into the wider world. Success – of a provisional sort, perhaps – is achieved only after many ups and downs; and comes about as much through Mandy's own efforts as through those of the adults around her.

Narration of these events, however, shifts between several different viewpoints, each associated with a particular set of cinematic codes. Harry's and Christine's story, in which Mandy's deafness is seen as a problem for the family and for their own relationship, is associated with a certain melodramatic expressivity in the image (low-key lighting, shadows). A 'documentary discourse' details the development and learning problems posed by the disability of hearing impairment, showing – through detailed visual explication of methods of teaching deaf children – how these problems can be overcome in the real world. Finally, Mandy's own discourse 'speaks' muteness and isolation through distortions of sound and image, repeated at key moments of her development, and conveying information, for the film's spectator alone, concerning how the little girl feels and why she behaves as she does.

For example, the narration of the scene in which Mandy first

learns about sound draws us into her frustration and rage at not
understanding what the teacher expects of her. This short scene is
composed of more than thirty shots, some of them, especially
during the exchange between Mandy and the teacher around the
mid point of the sequence, extremely brief. This latter section is
composed largely of shot–reverse shot figures involving the two
characters, and includes a series of six shots in this pattern, starting
when the sound of the teacher's voice encouraging Mandy fades
from the soundtrack and the camera tracks in to a big, distorted,
wide-angle closeup of the face of the child, disturbed and uncom-
prehending, as her lips touch the balloon the teacher is using to
demonstrate sound vibration.

The moment of silence – Mandy's auditory point of view, so to
speak – is then broken: failing to understand what is required of

her, Mandy breaks away from her teacher and starts to scream and cry. This little series of shots – echoing, in its organisation of sound and image, Mandy's previous moments of frustration – functions at this point in the film as prelude to the moment of breakthrough. This is given in a repetition of the earlier close shot of Mandy with the balloon, now with sound added: Mandy's voice articulating 'b'. She has finally understood what sound is. It is a moment of condensation, in both aesthetic and psychoanalytic senses.

Mandy's story, then, is not merely a series of events, but also a particular manner of narrating those events. Here must lie its powerful appeal to the little Annette, since my own childhood memories of the film are composed largely of visual and auditory flashes of those very crisis moments of Mandy's.

If Mandy's story traces a child's entry into language, albeit – because of her handicap – a peculiarly difficult one, this must also be the story of any childhood. Every child has to learn to speak, naming exactly the objects Mandy names – the first word she attempts (unsuccessfully) is 'baby'; her first achieved utterances are 'Mummy' and then her own name. She names parts of her world and names herself, making them separate from each other, placing herself apart from these objects and from the world. But at the same time, she must try to bridge this newly created gulf between herself and the world by means of the very thing that has created it, using language to hear and speak to others, to communicate.

Every child surely knows the loneliness of not being heard, not being listened to; knows, too, the desire to heal the rift between itself and the world. Every child, naming itself, sets itself apart

from those closest to it, living the pain of separation, struggling with ambivalence towards those others from whom it demands both union and separation.

Mandy's preoccupations are those of any six- or seven-year-old: she is ready to become a social being, to make contact with people outside her family, play with other children. One of the most poignant moments of the film occurs when we first see the six-year-old Mandy. Christine, over a long shot of her daughter playing alone in the backyard of her grandparents' house, says: 'She spent the next five years being sheltered.' We cut to a medium closeup of Mandy looking through a wired-over gap in the brick wall of the yard; then to a shot, from Mandy's point of view, of children playing at a distance on the waste ground that lies on the other side of the wall. Finally, we return to a forlorn-looking Mandy. She is wearing the same winter outfit as the one she will have on in the film's final scene – presumably a year later – in which she will at last leave the house of her own volition and enter the world of the children. These two scenes mark the beginning and end points of Mandy's own story in the film: five or six years of 'normal' childhood have been condensed into one for her.

If Mandy is like any child of her age, then, she is also other, different from 'normal' children: this is why we are told her story. I am like Mandy, and yet not like Mandy: in wanting to reach out to her as other, in recognising her difference from me as much as her similarity to me, I learn through her story to understand the sufferings of others. Perhaps this film, and the child's response to it, embody a moment of learning to see others as both separate from, and also as sharing things in common with, oneself.

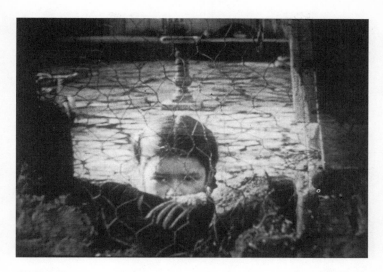

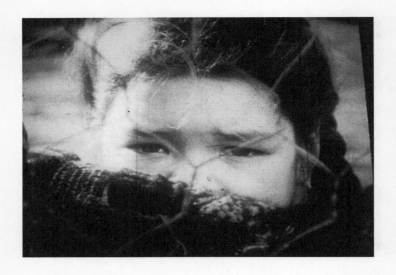

At such a distance of time, is it possible to disentangle the universal from the personal in all this? From today's vantage point (but at what level does a six-year-old know these things?), I can perhaps see parallels between Mandy's position within her family and mine within my own. But if a child's response to a film does resonate with the personal as well as with the universal, or perhaps rather draws the universal into the personal, does such a response not also connect with the historical moment of the film and its viewing?

Mandy was released seven years after the end of the Second World War; and although not overtly 'about' postwar Britain, the spaces of its narrative are certainly marked by the traces of war, most insistently in the image of the bombsite that lies behind the

house of Mandy's grandparents and figures in several of the film's key moments, including the final scene.

At the close of the scene early in the film when the two-year-old Mandy is brought to live at her grandparents' house, we see the bombsite for the first time in a high-angle point-of-view shot from a back window of the house. The shot takes in not only the waste ground itself, but also the house's small paved backyard and broken wall which demarcate the spatial relation, the proximity, of house and bombsite while at the same time pointing up the barriers between them – window, yard, wall. With the single significant exception of the final scene, the bombsite image is subsequently always introduced by this point-of-view shot.

This first bombsite image dissolves to the same scene, now – as Christine's voice-over tells us – five years on. Mandy is alone in the

backyard, while in the far distance, separated by the wall and a good deal of empty ground, a group of children is noisily at play. The world outside the house and the yard is fraught with peril for Mandy: she follows her little dog out through the back gate, accidentally left open, straight into the path of a lorry.

The same shot appears for a third time following Christine's first visit to the Bishop David School. Mandy – once again alone in the backyard – is riding her tricycle around in circles. Three scruffy boys appear at the hole in the wall: 'Hey you! Give us a ride!' Mandy, mute and uncomprehending, shrinks back. 'Stingy! Stingy!', the boys taunt. The next shot reveals that the point of view on this scene has been Harry's: inside the house, the family is discussing Christine's proposal to send Mandy to the school. Harry refuses.

Next time, though, the point of view is Mandy's own. Brought home from school, she is bored and lonely. She wanders into a room in which her grandfather is absorbed in solo chess, and looks out of the window at the bombsite and the children at play. A little later, a tracking shot, apparently unmotivated, moves us from inside the backyard and through the open gate, revealing Mandy in long shot from behind, moving tentatively towards the other children. She has left the house of her own volition, is making her approach, and will eventually be drawn into the others' game, seen (and heard) by her parents, who have followed her out of the house. A crane shot then reveals the entire setting in a high-angle extreme long shot, as Mandy runs into the circle of children. As the film ends and cast credits roll, the children resume their game, watched at a distance by Harry and Christine, now reunited.

The waste ground, it is clear, plays a crucial role in Mandy's story, figuring critically in her strivings to grow, move beyond the family and make contact with others. If the first step in this direction is made through the mother's agency, it is Mandy herself who pushes things further, naming herself and bridging the gulf between herself and the hearing children. The space beyond the house and the barrier between that which belongs to the house – the yard – and that which belongs to the outside world – the waste ground – become in effect the arena of Mandy's struggle. In order to name herself, become her self, she must first make her passage from the one space to the other. The track through the open gate marks this moment of Mandy's passage and triumph.

As a bombsite, the waste ground obviously acquires a certain verisimilitude with regard to the film's historical moment. At the same time, though, it is an odd – even an uncanny – image, with its strange juxtaposition of grand town house against a wilderness of destruction dotted with noisy, unruly children. It calls to mind those depictions of wartime London that point up the surreal character of the scene. If the bombsite image refers back to the actuality of war, this is a troubled and a troubling reference: confounding any notions of naturalism or actuality, it gestures towards more archetypal associations – the wilderness, the testing ground, the field of combat. Moreover, in the context of this particular film, further layers of meaning accrue to the image: it is associated with Mandy's personal struggle with isolation and loneliness; but its connotations also reach outwards to embrace issues concerning what it is to be a child – not only at a particular moment in history, but in general. This waste ground, this image, assumes a mythic quality.

If Mandy's quest – to acquire language and enter society – is

that of every child, hers is accorded extra resonance: not merely by virtue of her specialness, her disability; but by the highly charged mise-en-scene of the key moments of that quest. Up till the final scene, the image of the waste ground, with its accompanying distant voices of children at play, is always motivated by, and mediated through, the house. This makes the bombsite an object of desire for us as much as for Mandy: and for it to be attained, separation and distancing from the house are required. But what sort of object of desire is a piece of land devastated by war, portrayed as troubling, uncanny even? If this space stands for the future towards which Mandy is striving, then is there not some measure of ambivalence about that future: on the one hand a wasteland of destruction, on the other a *tabula rasa* for the construction of the new; on the one hand surrounded by old buildings, signifiers of the past, on the other clamorous with the life and energy of the young?

The mise-en-scene of the bombsite speaks a preoccupation that, unspoken yet insistent, pervades the entire film: the relation between past and future. It suggests that the future is rooted in the past, that the past will leave its marks on the future. The physical settings of the film's story might appear ugly or scarred, and the older generation flawed in their inability to communicate; and yet the life, joy and energy of the new generation stand in marked contrast to such gloom. *Mandy* is about one child's efforts to overcome a disability and seize life. On another level, it is about every child's quest to move into the world and learn to live with others. If the film also speaks more generally about overcoming the drawbacks of an old order by building a new one on its ruins, does this not suggest at least a guarded optimism about the future?

Such a reading assumes some obvious connections between

Mandy and its moment, the years of postwar reconstruction in Britain. *Mandy*'s message is historically grounded through an overlaying of the story of one little girl on the one hand by that sense of renewal and possibility always embodied in the figure of the child and on the other by a notion of rebuilding and renewing a social order.

If a reading of *Mandy* which properly engages the film text, its social–historical context, and the emotional responses it invites, eluded my earlier analysis, this is now made possible by attending, on the insistence of the little girl who wants to be heard, to Mandy's story, the child's story. The child Annette urges the adult to reach back into childhood, to trust the naive response and admit it to analysis; to understand that if she lets it, the film *Mandy* can return her, with an adult's understanding, to the child's world of possibility and loss. The little Annette also shows me, a child of Mandy's generation, how possibility and loss are written into the world my generation inherited; how they are written into our very expectations, as children coming to consciousness with the traces present all around us of a war we did not live through – traces in our physical surroundings, in our parents' talk, in so many aspects of our daily lives.

This detour through the world of childhood, with my own childhood self as guide, heals and teaches. It heals because it allows the child and the adult to speak to one another, lets the adult recapture the child's spirit of bravery and sense of possibility. It teaches because it shows that understanding may be gained by routes other than that of intellectual detachment. If an intellectually detached approach to reading a film produces results – as it clearly does – it

45

takes the child's wisdom to show us that such an approach may sometimes stand in the way of other, equally rewarding, ones; and that we should perhaps allow ourselves to look at things afresh, not casting aside our analytical procedures but using them differently, making greater demands on them.

The analytical material of this case history is less a child's response to a film than a child's response admitted to adult memory: for the child's response can only speak through the adult's interpretation. Given this, film theory, cultural theory, can surely risk a tentative embrace of 'feeling', of 'naive' response, whilst yet avoiding abandonment to the apparently unanalysable – the immanence of pure emotion, pure experience. If the results are modest, the shift that produces them is potentially momentous. Memory work presents new possibilities for enriching our understanding not only of how films work as texts, but also of how we use films and other images and representations to make our selves, how we construct our own histories through memory, even how we position ourselves within wider, more public, histories.

4

A Credit to Her Mother

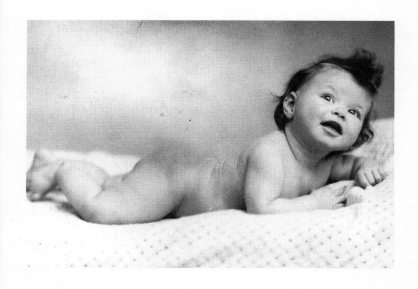

My family photograph collection includes two copies of the same studio portrait of myself at four months of age. The baby is naked, lying tummy-down on a blanket, facing camera but looking upwards to a point somewhere above camera level. This, as far as I know, is the earliest photograph taken of me; and one of my copies of it accordingly features on the very first page of the photograph album I began putting together when I was eight, in an effort to make both a family and a life history for myself. The other copy, sent to me by my mother long after I had left home, grown up, and broken contact with her, bears a lengthy inscription on the reverse:

> Thought perhaps you might like this. You were a beautiful baby from the minute you were born. I loved you and you were always immaculate and well cared for. Your hair was very dark and there is a great resemblance to Marion and Samantha. Written in pencil, you may want to erase.

This inscription, pointing up a likeness between my infant self and my two nieces, the only daughters of my two much older half-brothers, was obviously written at the time the picture was sent to an adult and estranged daughter. The copy of the picture which carries this message – my mother's copy – has been trimmed, so that the area of the image which had been background and not baby is cut away.

Two copies of the 'same' photograph, then; but embodying very different uses and meanings at different moments for the various people with investments in it: the parents of the newly-born baby, the child herself as a little girl, the mother of the adult daughter, the

daughter as an adult. In itself, the image carries meanings outside these immediate contexts, too, revealing a great deal about how infancy is understood in a particular social and cultural situation.

The baby's nakedness, suggesting newness, naturalness, innocence, is set within particular conventions of photographic portraiture, which in turn mimic high art conventions – notably, but not exclusively, those of the (adult, female) nude – suggesting that this is no mere snapshooter's effort, but a professional piece of work. In the process babyhood in general, a particular baby, and a specific image are elevated, made special, lifted out of the ordinary, the everyday. My photograph is in these respects no different from the thousands, the millions even, like it: it speaks volumes about the cultural meanings of infancy, the desires our culture invests in the figure of the newborn child. But while such meanings are certainly present in the specific contexts in which images like this are produced and used, every image is special, too: gesturing towards particular pasts, towards memories experienced as personal, it assumes inflections that are all its own. My photograph, then, is the same, and yet it is different.

On the surface, the family photograph functions primarily as a record: it stands as visible evidence that this family exists, that its members have gone through the passages conventionally produced in the family album as properly and necessarily familial. My photograph thus records the fact that a particular child was born and survived. But recording is the very least of it. Why should a moment be recorded, if not for its evanescence? The photograph's seizing of a moment always, even in that very moment, anticipates, assumes, loss. The record looks towards a future time when things will be different, anticipating a need to remember what will soon be past.

49

Even for outsiders, family photographs often have a poignant quality, perhaps because they speak all too unerringly of the insufficiency, the hopelessness, of the desire they embody. Time has passed, time will pass. The image of the infant, innocent in its nakedness, naked as the day it was born, cannot so much fix that moment of innocence as testify to the inevitability of its slipping away, of a slippage from grace. Hence the sadness, the sense of loss and longing, I read in my mother's words. 'You were beautiful', she says; beautiful, pristinely, 'from the minute you were born'. Her choice of the word 'immaculate' here is telling: I was, she recalls, spotless, unsullied, free from sin or stain; precisely in a state of Edenic innocence.

Perhaps the mother's recollection speaks a degree of identification with the baby – a desire that she, the mother, might partake of the newborn's innocence; that in giving birth she too will have been reborn, granted the gift not just of innocence but of a fresh start. More specifically, the 'immaculate' may be read back to the baby's very conception; as an expression of my mother's wish (which might well have been retrospective – written into the past constructed by her inscription, that is) to have been my only begetter, for me to have been hers alone. The reference to my nieces, my brothers' daughters (one of whom I have never met) – in effect negating the role in my conception of the man I knew as my father, who was not the father of my brothers – would certainly support this reading.

It seems, then, that the mother's love for her baby, not least in its retrospective assertion, is far from unambivalent. 'I loved you', she tells the grownup daughter who has left her. Loved me once, that is, in my immaculate, unspoiled state. Which suggests that this love

50

had a hard time, and very likely failed, to survive the loss of innocence, to survive the baby's growing older and the mother's learning the hard lesson that life carries on much as before, except that now there is another mouth – and one that talks back, into the bargain – to feed.

In readings which shift back and forth across contexts – from the cultural to the familial to the individual to a specific constellation of family relations – the notion constantly re-emerges, in different shapes and forms, of infancy as spotlessness, innocence; and of the figure, the image, of the newly-born child as embodying at once a desire for return to innocence and a knowledge of the absolute impossibility of such a return.

It is also clear, though, that the naked and 'immaculate' body of the newborn Annette figured for my mother as *tabula rasa*, an empty slate, on which her own desires could be written – in an endeavour, perhaps, to repair lacks of her own. Born fourth in a family of seven, the fourth daughter of a man who desperately wanted a son, she felt she had never been wanted, loved, or cared for enough, certainly by her father (in her account a violent man and a poor provider) who despite – or perhaps because of – his absence at war figured overwhelmingly in her childhood memories. (In a book-length memoir written when she was in her sixties, my mother recalls her father's first return home on leave from the war:

[I]t was in 1915, and our Dad seemed to have been away for ever. But one day during the Summer holidays when we were playing on Moor Mead, a girl came running up to us and said, 'I think your dad's come home. A soldier went in your house'. Without waiting to hear the last of what she was saying, I was on my way home, my

bare feet hardly touching the warm pavement . . . There in the kitchen was my dad, sitting in an armchair near the fireplace. I wanted to climb all over him, but before I could reach him, he said in a very stern voice, 'Where's your shoes? Put them on at once! . . .'.)

It seems clear to me today that my mother's love for the 'immaculate' baby Annette was marked very much by a quest to love the abandoned and unloved child she herself had been: in other words, that this maternal love involved a work of identification; identification then subjected to threat through that erosion of the ideal that comes with the inevitable loss of the innocence attaching to the figure of the baby. My mother's inscription on, and indeed within, the photograph, made when her baby had grown up and to all intents and purposes decisively separated herself, speaks with some eloquence of these investments, their failure, her disappointment.

In the Eden myth, the moment of the fall from primal innocence is marked by Adam and Eve's covering their nakedness; and, significantly, in the family album nakedness is admissable only in photographs of babies and very young children. My mother tells me that not only was I beautiful in my natural state, from the minute I was born; I was always well cared for, too – well cared for, of course, by her: well turned out, in another favourite phrase of hers. 'Immaculate' here then partakes not only of the natural but also of the cultural: the newborn's primal innocence is overdetermined by – perhaps even subsumed to – the mother's labour of care for her child.

When my mother says I was well cared for, I know quite well that she is referring as much, if not more, to a public presentation

of a 'well turned out' child ('a credit to her mother', she would often say of Marion, the niece whom she maintains I resembled) as to any less outwardly apparent caring or 'maternal love' on her part. Or rather, perhaps, that for her the two things are inseparable: one loves one's baby, of course; and the evidence and the guarantee of that love lie in the labour of care evident in the child's appearance. But there is more to this than mere display. The baby's body is here quite literally a blank canvas, screen of the mother's desire – desire to make good the insufficiencies of her own childhood, desire to transcend these lacks by caring for her deprived self through a love for her baby that takes very particular cultural forms.

In my mother's account, her childhood was deprived materially as well as emotionally, and for her the two types of lack were inseparably intertwined. In this context, loving becomes synonymous with having – or rather with being given – enough to eat and decent clothes to wear (the detail of the bare feet in her memory of her father's homecoming is, I think, significant). This perhaps explains the enormous investment, in all senses of the word, in my appearance: not just in my clothes, but in my hair; which for special occasions, and with huge effort on her part and much discomfort on mine, my mother would tie in rags to make the ringlets she herself had worn, or would have wanted, as a little girl. As I grew older, she took an interest in my body language as well, trying to get me to stand straight and not slouch: 'Back up, tummy in!' For if I failed to be 'well turned out', that failure would surely be hers, and she would be exposed as a bad person: not just an unloving mother, but – worse, perhaps – an unloved an unlovable little girl.

I am my mother's only daughter, and her youngest child, always

to my irritation referred to as her 'baby'. My childhood was nonetheless punctuated by many births in the family, of the children of my two brothers and of numerous extraordinarily fecund cousins: births of babies and talk about babies were, it seemed, endless. Among the favourite topics of conversation, especially among girls and women in the family, was the sex of a forthcoming baby: will it be a boy or a girl? and which would be preferable? There was a solid, perhaps an overwhelming, body of opinion that girl babies were on the whole the better deal, because 'you can dress a little girl up'.

On this conscious level, at least, a mother's attention to her baby's appearance has everything to do with gender: her love for a girl infant will be legitimately expressed in ways different from her love of a baby boy. Significantly, my mother's description of my niece Marion as 'a credit to her mother' was never applied to Marion's two younger brothers.

In the summer before my fourth birthday, a photograph was taken (possibly by my father) of my mother and me on the front lawn of our ground-floor flat in Chiswick, West London. It is the only picture I have of myself as a small child with my mother. In this one, I am seated on my mother's knee as she grips me firmly in the crook of her left arm and rests her right hand across my ankles. We are both looking at camera; and I am clutching a doll and wearing a tartan dress with puffed sleeves and matching underpants, and a bow in my hair. On the back of this photograph my mother has written: '. . . Chiswick. She was nearly 4 years old. Dress and knicks by me.' Again the picture has been trimmed, and part of the inscription cut away as a consequence.

This picture disturbs me somewhat: a feeling, I think, which has

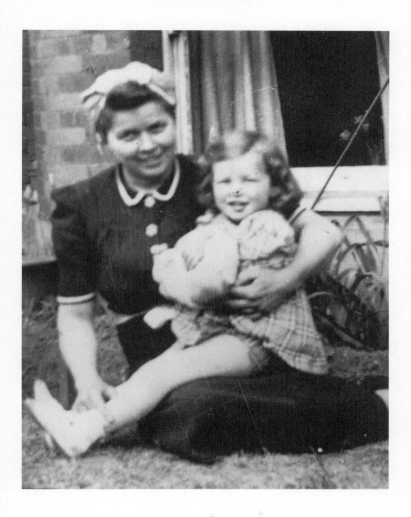

a lot to do with my mother's uncharacteristic presence in the image. On the surface, it seems a commonplace and happy enough example of family photography. But beneath the sunny facade lurk shadows: the mother-father-daughter triad the picture (assuming it was made by my father) points to was not in fact a 'real' family. The child being held so tightly was an intrusion. If I put myself in the position of my mother as she was at the time this photo was taken, somewhat younger than I am now, all sorts of ambivalences surface.

She holds on firmly to this little girl who is hers, whom she per-haps desires to be hers alone. But children, as she would often remind me, tie you down. When I came along, unintended, her younger son was thirteen and she thought she was finished with childrearing. Life had not been easy with the boys and their father, and now in her late thirties she was hoping, at last, for a good time. If she did find a bit of fun with my father, though, she had been thrown her back to square one by its consequence: me. Trapped in a situation she had not bargained for, my mother was tied for the foreseeable future to a child she had neither planned nor wanted to have, and (in days when the concept of the single-parent family had yet to be invented) to a man she would grow to despise.

But if the child was a mistake, she was not entirely a misfortune: she was a beautiful baby from the minute she was born, her mother's only daughter, who would always be her baby. The care and pride that have been lavished on the little girl's appearance are visible in this picture, which is readable – and, I would contend, was certainly read by my mother – as evidence, proof of that care. This is underlined in the statement, seemingly addressed to no-one in particular, that the little girl's outfit was of her, the mother's, own making.

Children are a costly commodity: their upbringing calls for hard cash, as well as a good deal of labour of various kinds. This, though (we are told), ought to be a labour of love, entered into freely and without reservation. Counting the cost is not appropriate. Sure enough, the family as it is represented in family albums is characteristically produced as innocent of such material considerations, above price: to this extent, the family album constructs the world of the family as a utopia. And yet I feel sure my mother, whose own childhood had been so marked by poverty, must have known, or even calculated, the exact cost – to herself, at least – of having and keeping me. Perhaps in my earliest years her economic and her emotional investments measured up to each other, so that her identifications – of her baby with the unloved little girl in herself – could proceed unchecked. In these honeymoon years, being the mother of a well turned out baby must have provided enormous pleasure and emotional reward.

Keeping up appearances could not have been easy, though. From my earliest years, perhaps right from my infancy, both my parents worked outside the home. When I was very small, they shared responsibility for cleaning the public areas of the block of flats where we lived and of which my father was caretaker. They also worked together in my father's photography business, and both had jobs as bus conductors. While I do not know whether these jobs were simultaneous or consecutive, nor indeed whether there were any periods when my mother was actually at home full-time, it seems clear that a lot of hard work was being done to earn the means to keep the household going; and that there would have been little in the way of leisure time for my mother to pursue dressmaking as a hobby. Since, however, clothes were still 'on the ration',

in common with many others during the years of postwar auster-
ity, she would simply have had to find the time to 'make do and
mend'. In this climate, making clothes for herself and her baby was
probably a necessity more than a hobby.

Whatever the case, though, keeping the baby 'immaculate and
well cared for', while a source of pride and pleasure, must still have
cost a good deal of effort. Hence the ambivalent feelings of a
mother whose life and circumstances had been, indeed remained,
far from easy towards a baby born into a world which held out the
promise of new opportunities for the children of ordinary working
people; a baby, moreover, who seemed to be the object of all the
love and attention she herself had been denied; a baby, nonetheless,
who would one day grow into a woman in a society still unkind to
those of her sex.

Thus may a mother's investments in her baby daughter, inflected
by particular circumstances of time, place, culture and class, meld the
social with the psychic. This mother's ambivalent identification with
her baby daughter already contains the seeds of overidentification,
of difficulties of separation. If a daughter figures for her mother
as the abandoned, unloved, child that she, the mother, once was,
and in some ways remains, how can mother and daughter
disengage themselves from these identifications without harm,
without forfeiture of love? How can mother and daughter learn
to acknowledge that they are separate people, to respect their
differences from each other?

Any resolution, it seems, must come with very great difficulty:
there will inevitably come a moment when it is no longer possible
for the mother to sustain the fantasy of her daughter as *tabula rasa*,
of the daughter's body as screen of her own fantasies of plenitude.

The child will one day start answering back, refusing the mother's 'gifts', along with the vision of the perfect, immaculate, well turned out, little girl. At this point, matters of appearance, including clothes, may well cease to be a source of pleasure for the mother, and even become a site of struggle between mother and daughter.

'You can dress a little girl up' is one of those statements, certainly in the context in which I quote it here, whose truth is assumed to be perfectly self-evident. It points to one of the obvious and most important pluses of having (and not, it should be noted, of being) a baby girl. As a piece of conventional wisdom, it condenses a range of commonplace and generally unremarked cultural associations between dress and gender. But it also asserts a good deal more than that, say, there exist distinct forms and styles of dress which are very much tied to gender. It implies as well that the ways in which we actually relate to clothes and to matters of appearance in general are a ground, as much as an outcome, of sexual difference.

If, for infants themselves, sexual difference is hardly yet an issue, it certainly figures very prominently, and often in unconscious and contradictory ways, in adults' attachments to babies and very young children. 'Dressing a little girl up' is held to be an occasion of rightful and proper pleasure, and reward, for its mother; the unspoken corollary perhaps being that while a boy will obviously have to be clothed, this is more of a functional necessity, and that to dress him up in a way that goes beyond tidiness or smartness might be inappropriate. In this particular social, historical and cultural context, at least, the investments in a mother's dressing a boy baby and dressing up a girl baby are assumed to be quite distinct.

In this context it may well inadmissable for a mother to claim, by word or deed, any pleasure in dressing a little boy up, as opposed to merely dressing him: for this in effect would be a confession that she was disturbing the natural and proper order of gender difference: making a cissy of him.

But even such a forceful prohibition as this cannot account for the *positive* pleasure a mother may take in 'dressing up' her little girl. For the mother, the labour of attending to the appearance of a girl baby is surely of a very particular kind: it is caught up in that series of investments and identifications at play in general in her care of her little daughter. Dressing up a baby girl is a socially sanctioned opportunity for a woman, in caring for the little girl in herself, to love herself; while at the same time providing her with the opportunity to display, for the public gaze, the praiseworthy qualities of an adult who puts the needs of others above her own: a good mother, in other words, and therefore a good woman.

In a number of ways, therefore, having a baby girl she can dress up might be intensely rewarding for a mother. However, the distinctions between dressing and dressing up on the one hand and between having and being a baby girl on the other signal areas of potential contradiction, and are thus perhaps worthy of further exploration. Dressing up as opposed to mere dressing implies, as has been suggested, a more than purely functional attitude towards clothes: it points to the element of display, of performance, inherent in certain relations to dress. Clothes are what you put on and take off, and consequently various identities may – sometimes quite consciously – be created across the surface of dress. This element of performance holds within it the potential of prising apart the gender/dress association, and this in turn

can disturb the order of gender difference naturalised in certain clothing styles.

The naturalised order of gender difference rests on more than just the forms and styles of dress, on differences as it were in the *content* of clothing: it is a question of forms of relation to personal appearance more generally, to the entire realm of bodily adornment. Dressing up – like its cognate activities *making* up and *doing* one's hair – suggests a relation of fabrication, construction, production. Herein lies an interesting paradox: dressing up a baby is possible, indeed socially acceptable, provided – and because – the baby is a girl; while (less consciously, perhaps) dressing up will also actually produce any baby, male or female, as feminine. As long as one baby in its clothes could look much like any other, outwardly visible marks of gender (the colour coding of baby clothes, for example) acquire a certain importance. In this context, while dressing up is part of the production of gender, it also gestures towards the very artifice of that production.

A mother's attention to the clothing and general appearance of a baby girl, then, participates in the social, cultural, and undoubtedly also the psychical, construction of gender; specifically, of course, of femininity. It fabricates something we are supposed to believe is natural, already there; and so reminds us that femininity is not in fact a given, but is a product of labour. But in the specific instance of a mother's dressing up a baby girl, the labour involved is also imbued with particular investments of desire, fantasy and identification; with the body of the baby figuring as pretext for what will be experienced as an enjoyable creativity. In this sense, the baby girl becomes its mother's muse, its body her canvas, the dressed up little girl her mother's very own work of art: to be

looked at, admired, photographed, and hailed as a credit to her mother.

The often arduous and time-consuming work of producing a well turned out baby girl then becomes an end in itself, its results apparent, its use value palpable. This is visible and unalienated labour, whose product bears, for all the world to see, the signature of its maker: indeed, the most satisfying sort of work. The end product becomes identified with, reflects back on, the worker herself, the mother, just as it constitutes the baby as a little girl. As, through this labour, femininity is produced in and through costume, through masquerade, so a mother's investment accrues to her credit. Clothes, as they make the little girl, also make the grown woman.

The mother's fantasy of identification (in which she cares for her little daughter as she would be cared for herself, and produces the baby in herself as a beautiful little girl worthy and deserving of love) rests upon a degree of projection, the baby its object, its screen. In the processes of projection and identification, the baby is fantasised as part of the mother – who can then simultaneously have, and be, the baby girl. In both senses, the baby becomes her mother's possession, and the play with femininity involved in dressing her up part of the mother's own involvement with femininity and its paradoxes, its ambiguities and its masquerades.

In this respect, the mother's pleasure in dressing up her baby girl may not be entirely unalloyed. Aside from the possibility that her care for the child could be an attempt to repair, to compensate for, deprivations in her own childhood – in its very nature a highly problematic project – the mother must on some level also be aware that the femininity she is calling forth in the masquerade of the

dressed-up little girl is not without its complications and contradictions in the world beyond the mother–baby dyad.

Related to this must be the virtual inevitability of the mother's fantasy of oneness with her baby girl coming unravelled: for as the child grows older the fantasy of the baby as the screen of its mother's desire will become increasingly difficult to sustain. It is here that the distinction between having a baby girl and being a girl child comes into play. What happens when the child herself intervenes in the dressing up process, perhaps to assert her own wishes about her appearance? How, in such a circumstance, can a mother protect her investment? How can the child continue to be a credit to her mother? And what sort of story might the little girl herself have to tell about all this?

One of the manifestations of my own mother's involvement with her daughter's appearance was a passion for fancy dress. My photograph collection bears witness to the fact that, until I was around eight or nine years old, I took part in numerous fancy dress competitions. This was entirely my mother's idea: she entered me in the contests, made the costumes, and exhorted me to display them to best advantage. A frequently expressed conviction of hers had it that costumes she called 'original' (which for her meant conceptual as opposed to mimetic) stood the greatest chance of winning; and that if an 'original' costume did fail to net a prize, it was still far superior as fancy dress to the obvious, and perhaps more acceptable, sorts of costumes little girls might be dressed in for these occasions – nursery rhyme characters, fairies, princesses, brides, and suchlike. While I cannot in truth say I would have preferred any of the more conventionally little girlish costumes, in what I did wear I nevertheless

did feel exhibited, exploited, embarrassed. Even if I won, there was little pleasure in competing in this way – in being put on display, scrutinised, weighed up, given points, judged. As I grew older, I grew less willing and no doubt decreasingly compliant.

A photograph of me wearing the costume for what I believe to be the last fancy dress competition I entered shows me, aged about nine, wearing a long shift to which are attached empty cigarette packets, drinks cartons, ice-cream containers, drinking straws, matchboxes; with a headdress comprised of one waxed Kia-Ora orange juice carton flanked by a pair of ice-cream tubs. On my right arm rests a placard explaining the costume – 'Cinema Litter'; and on my left a jigsaw puzzle, presumably my prize. It is difficult to put a precise date to this photograph, partly because, like the others, it has been trimmed down: the background is consequently minimal, offering no clues as to location; and whatever had been written on the back of the picture has been almost completely cut away.

(I find myself extraordinarily, perhaps excessively, troubled by this habit of my mother's of cutting photographs down. The historian in me objects to the tampering with evidence; the critic to the lack of respect for image composition. But the strength of the feeling really has to do with the fact that these acts of my mother's seem to me to be gestures of power, at once both creating the evidence that fits in with her version of events and destroying what does not; and also negating the skills and aesthetic choices of the photographer, usually my father. This particular photograph certainly looks like one of my father's efforts: if so, it must be among the last pictures of me he made, for by this time he had more-or-less given up what was in any case by now no more than a hobby.)

In the context of my own memories, I see this photograph, which I find very painful to look at, as a 'cusp' image, marking a transition. It must have been made at around the time of our move away from my first home in Chiswick to live in the house of my recently deceased Granny, my mother's mother. This move was highly traumatic for me, in large part (as I now construe it) because although they remained together, leaving Chiswick marked some decisive rift between my parents.

Our new home was very much my mother's territory: it had been lived in not only by her mother, but before that by one of her brothers. Over the following few years she saw to it that both her sons moved with their families into other houses on the same street. In all this, I believe my father must have felt increasingly marginalised: illness – he suffered from bronchitis which later became emphysema – by now dominated his life and isolated him from those closest to him. This, along with his abandonment of the hobby of photography, which had been a source of such pride and pleasure, must surely be symptomatic. I, too, felt displaced: in my new school, corporal punishment – completely alien and shocking to me – was practiced; I was mocked by the other children for my 'posh' accent; I even caught head lice and had to have my plaits chopped off. Desperately unhappy, I started putting on weight.

It was around this time, too, that I started 'answering back', embarking on a lengthy and bitter struggle with my mother over issues of separation – issues which would never finally be resolved. I recall feeling unhappy about being put into this particular costume and into the fancy dress competition, and had doubtless let my objections be known in the various overt and covert ways of the

uncompliant child – whining, sulks, refusal to smile and a general 'slouching on parade'. If the photograph itself reveals nothing of all this, neither, though, does it seem to me to present an entirely untroubled surface.

The girl looks neglected and slightly scruffy, a far cry from the 'immaculate' three-year-old. Little effort seems to have been put into her hair, badly cut (could this have been soon after the head lice episode?) and all over the place; her smile seems slightly doubtful; her eyes are closed. The costume is even more illuminating. In itself, it is certainly a clever idea: but more remarkable is the fact that the child wearing it is being displayed as a figure for the detritus, the discarded byproducts, of a pursuit whose pleasures hold a distinctly erotic appeal. The implications scarcely need spelling out: it is fortunate, perhaps, that this was to be the last of my fancy dress costumes.

My mother's passion for fancy dress can be regarded in certain respects as an extension of her earlier investment in 'dressing up' her infant daughter: though there is undoubtedly more to it than that. As a cultural form, fancy dress gestures with some urgency towards the performance aspect of clothes. Indeed, it renders this aspect entirely overt: for the whole point of fancy dress is that the masquerade is there, self-evident, on the surface. Fancy dress partakes of the carnivalesque, a turning upside-down of the everyday order of hierarchies of class, status, gender, ethnicity. A bus conductor's daughter can be queen for an hour – or even, indeed, king, for girls can be boys and boys girls, and either can be neither. A fracturing of the clothes/identity link is thus sanctioned – at once permitted and contained, that is – by the cultural conventions of fancy dress.

Also, and relatedly, there is clearly a fantasy component to fancy dress: indeed, the word 'fancy' itself derives from a contraction of 'fantasy'. But whose fantasy? In the case of 'Cinema Litter', as of the other fancy dress costumes my mother made for me, certainly not the little girl's, certainly not the daughter's. Costume which presents itself so unequivocally as performance or masquerade will often – and certainly in the case of 'Cinema Litter' – beg to be read symptomatically. But while an interpretatation of 'Cinema Litter' reveals meanings tied specifically to a particular costume and context, taken together with all the other fancy dress costumes my mother made for me (and certainly if it is accepted that one of the issues at stake here is a mother's identification with her daughter) this can be seen as expressive also of fantasies of a rather different nature: the desire of a working woman, no longer young, to be noticed – seen, applauded, rewarded – as someone special, different from the rest, out of the ordinary, precisely 'an original'. The daughter in fancy dress, attracting attention, winning prizes even, becomes a vehicle for the mother's fantasy of transcending the limitations, dissatisfactions and disappointments of her own daily life.

But given the 'conceptual' and/or the androgynous quality of the costumes she favoured, it seems to me that at this point my mother's fantasy had little to do with femininity as a site of redemption, and much to do with a wish to overcome the limitations femininity imposes. To this extent, the unconscious aspect of the fancy dress project either runs somewhat counter to the earlier project of producing a 'well turned out' little girl, or underscores the contradictions and ambivalences around femininity that were already, perhaps, lurking in the latter.

While all this might bespeak resistance, or signal the (limited?) liberatory potential of certain cultural practices for individuals and social groups who lack power in the public world, it should not be forgotten whose fantasy it was that drove these particular practices of dressing up and the fancy dress. For the little Annette, her mother *was* all-powerful; and it seems never to have occurred to her, the mother, that her daughter could possibly harbour genuine feelings or wishes or hopes or ambitions that in any way diverged from her own, the mother's.

What, then, of the daughter's story: the daughter put on display, exhibited to the public gaze in a quest for rewards from strangers for costumes, for outward appearances, that by nature and intent cloak, occlude and subvert – as well as create – identities? What if the daughter was not entirely comfortable with such identities, with being the site of another's investments, the vehicle of another's fantasies? What of the daughter who refused to smile prettily at the judges, refused to want to be picked out from all the others as a winner, and yet who found utterly unbearable the humiliation of losing? What of her? That little girl got fat, looked terrible in everything she wore, and answered back. What a disappointment to her mother.

5

A Meeting of Two Queens

To mark the Coronation of the Queen, my mother made me a special frock; and on Coronation Day I was photographed wearing it.

The picture shows a seven-year-old girl posed in an outdoor setting, probably a garden. Standing in dappled shade, she wears a puff-sleeved party frock in a white muslin-like fabric, elaborately accessorised with a crown-and-tassel brooch at the collar, two big bows of ribbon in her hair, and a new handkerchief (bearing a crown and the motif 'EIIR' on the corner) tucked into a wrist bangle. A fraction of an inch of petticoat is visible below the hem of the dress. Posed a little stiffly, she looks at the camera wearing a solemn expression, possibly a slight frown.

My father took this photograph, most likely at my mother's request. My recollection is certainly that, having just completed the laborious task of dressing me and doing my hair, she was present when the picture was taken.

Why was the photograph made? Plainly as a record of a special occasion, as well of course as of the outfit itself. Produced (and consumed) within my family, this is obviously a family photograph; and

yet in content and composition it is closer to the formal photograph than to more common variants of the family photograph like the candid shot and the snapshot. There is in fact more than a hint of professionalism about this picture.

It has been shot outdoors in natural light; and some care clearly taken to make the best of prevailing conditions. The subject's slightly angled stance to camera suggests awareness on the photographer's part of professional protocols for arranging and posing subjects, as well as for framing and composing images. The slight technical difficulty of finding the correct exposure for a figure in partial shade clad mostly in white has been successfully overcome. The side lighting of the figure and the dappled shade at her feet are rather pleasing. A snapshooter would have posed the child facing directly to camera and stood with his back to the sun to shoot the subject four-square. He would probably also have included more of the background in the frame, and produced a flat, forward-lit image. Since one of my father's jobs around the time this photograph was taken was as a semi-professional photographer, it is hardly surprising that he was capable of producing an image of relatively high technical and aesthetic quality. This one was shot on 35mm film, and would have been developed and printed by my father himself, along with photographs he had made, commercially, of other people's children.

By the 1950s, when the home snapshooter's box camera had become commonplace, formal family photographs accounted for a rapidly decreasing proportion of all family photography. They function to record, to immortalise, something regarded as especially important by and for the family concerned: a rite of passage, a possession, a relationship, an occasion of special social

significance. Such events (graduation ceremonies and weddings, for example) are considered so special that it is still common today to commission professional photographs to mark them. In keeping with the gravity of the occasions they commemorate, formal family photographs typically involve careful and highly conventionalised settings and poses, and often an air of decorum, even of august-ness, on the part of sitters usually attired in some sort of special, non-everyday dress: Sunday best, uniform.

While largely conforming to its stylistic conventions, this photo-graph of a little girl in her Coronation Day outfit belongs to none of the usual categories of the formal family photograph. Rather, it calls to mind other sorts of formal photograph – the soldier in uni-form, for instance, or the school portrait. These share the ritual quality of all formal photographs, whilst celebrating occasions, connections or activities of significance outside the family circle: school, Brownies or Guides, military service, sports. The costume worn by the child in this Coronation portrait is not Sunday best; nor indeed is it fancy dress: it is ceremonial.

Ceremonial dress signifies that the occasion it celebrates sub-sumes the individualities of those taking part to larger communities; to attachments that go beyond, even overshadow, the personal lives of those pictured. Where ceremonial dress is con-cerned, the clothes are greater than the wearer. Even if destined to have no currency beyond family album or mantelpiece, a ceremo-nial image may none the less voice a profound desire not merely to be witness to, but actively to participate in, rituals through which a recognition of some collective destiny, a social sense of belonging, is sustained. This, I believe, is the testimony of this picture of a little girl in her Coronation dress: this is why the photograph was made.

But that is not all there is to it: the meanings of the photograph are both more and less than this. More, because this is only one of a number of possible readings of the picture; less, because even its ceremonial meaning is not entirely unambiguous. What, it might be appropriate to ask, does this photograph *not* show?

It does not, for instance, show whatever it is about the picture that always evokes in me an affective response of – how to name it? – conflicted guilt, perhaps. In my memory of the occasion, the manner in which I presented myself to be photographed was somehow wrong. The seven-year-old Annette knew this, knew what was expected of her; and yet, with halfhearted and slightly shamefaced defiance, made no shift to comply. She was meant, of course, to be (or at least pretend to be) delighted with her new outfit; meant to display her delight to the camera, and to the world, in the proper manner – namely, by posing properly and smiling nicely. Instead, she conformed grudgingly by standing to attention (but a little too rigidly, and certainly not very 'femininely') and assuming a smile of such pursed faintness as practically to verge upon a scowl. In consequence, she succeeded in displeasing both her parents: her mother, for not appreciating all the effort that had been put into her appearance; her father for failing to be a good photographic subject. At some level, the child in the picture understood all this, and felt ashamed; and yet still could not bring herself to behave like the good little girl she knew the grownups wanted her to be.

Today, as I imagine myself at that moment, inside that dress, my body feels constrained, my chest tight. I can scarcely breathe. The clothes are uncomfortable, restricting. The belt squeezes, the collar chokes. The top half of my body feels cramped and immobile. I hate the dress, in any case: it is fussy and overdecorated. There is

too much red, white and blue, and I dislike especially the excessiveness of the brooch and the precariousness of the handkerchief. I did not ask for, nor do I want, these clothes. The business of curling my hair has been painful: I have slept all night with it tied up in rags. And now it is frizzy, the bows are pulling, and my head hurts. I have already shown my aversion to the whole business by being uncompliant and irritable while being dressed: with the consequence that my body has been subjected to a good deal of poking, prodding and pushing. No wonder the child looks like a stuffed dummy.

Associated with this photograph is an indistinct but intense memory of sickness. Around the time it was taken, I was ill with bronchial pneumonia and spent what seemed to me a very long time away from home, first in hospital and then at a convalescent institution a long way away, where I received no visitors and some unaccustomedly rough treatment at the hands of the nuns who ran the place (they called me 'unhealthy child'). Oddly, given the urgency with which both the illness (it felt, feels, like a turning point) and the unhealthy child that I was force themselves into my memory, I find it impossible to be certain whether the photograph was taken before or after my (as I saw it) banishment. But there is always this memory-feeling attaching to it: I have not been well; this is perhaps the occasion of my return to full health; I am to understand that no further allowance will be made for unsociable behaviour on my part.

But the precise sequence of events matters less, perhaps, than their content: the memory of being ill, and the nature of the ailment. For the physical sensations I associate with the dress and the photograph – the tightness in the chest, the inability to breathe –

are, of course, exactly the symptoms of a bronchial condition. What is more, these sensations, these symptoms, mirror the sickness my father, as I remember it, had always suffered: chronic bronchitis, later to develop into emphysema. I recall no time when drawing breath was not an effort for him. His struggle to breathe repeats itself in the content of my own childhood illness, which then haunts my response to this photograph. Even today, at moments of stress, these symptoms return to my body.

Already, at the age of seven, I knew how little girls were supposed to feel about new frocks and being dressed up; about how they are supposed to respond to being put in front of a camera, Daddy's camera. It is equally clear that, even if rather half-heartedly and shamefacedly (I derived no pleasure from displeasing my parents whom, after all, I loved), I was refusing to wear it, almost literally. The attention was undesired: it felt overwhelming, an immoderate demand. So many gazes, so much scrutiny. Who or what did they – my mother, my father, the camera lens – want to see when they looked at me? It would be too easy, I think, to say that what they wanted was a pretty little girl who willingly made herself the adored object of her parents' gaze, and derived pleasure from being looked at, from pleasing them. No, the messages I was receiving about femininity were far less straightforward than that. Perhaps the grownups did not really know themselves – or perhaps they had differing ideas about – what they were looking for in me.

And yet the making of the dress, the care devoted to my appearance on this occasion, suggest that what was consciously intended was a gift. The dress, the preoccupation with the child's appearance, the elaborate mise-en-scene and composition of the photograph: all are displays, earnests of – what? Anthropologists

say that the rendering of gifts, in expressing the expectation that acceptance commits the recipient to be what the giver wants them to be, is in some respects an act of aggression. My mother's gift to me (I have much less sense of my father's investment here) was, I believe, directed more at the neglected little girl that she herself had been than to a daughter whom she might have regarded as a person in her own right. The dress felt – feels – tight, constraining. Surely, with its high waist and narrowly cut shoulders, it is too small, too young a style for a seven-year-old? (It was in fact cut from the pattern of the dress I had worn two years earlier as a bridesmaid at my brother's wedding.) At seven, I was outgrowing being my mother's baby, the little girl she had lost in herself but found in me. Letting go, perhaps, was proving difficult.

There is something about this photograph that reminds me of those formal portraits of themselves in full uniform that tens, hundreds, of thousands of ordinary soldiers fighting in the First World War commissioned to give their loved ones: not only as mementoes of their lives – and so often of their deaths – but also as records of service to their country. I remember, too, that my mother's father left home to go to that same war when she, my mother, was only seven years old, my own age at the time the Coronation photograph was taken. I recall, too, that she always spoke with a longing clouded with bitterness about this man, absent for so much of her childhood, who never gave her the attention nor the love she wanted from him. The particularity of this lack, this longing, surfaces in my mother's fondness for uniforms of all kinds, however lowly: an attraction in which desire and identification are blended in equal parts. Like many women, she 'loved a man in uniform'; but many of the work and leisure activities she chose for for herself

(bus conductor, Civil Defence volunteer) called for uniform, too. She harboured considerable nostalgia for Empire Day and its elaborate observance in her youth, and on its pallid latter-day equivalent, Commonwealth Day, would make a point of sending me to school in my Brownie uniform, and carefully explaining why.

My mother's investment in my appearance; her gift to me of this would-be uniform, a Coronation dress; her desire to commemorate a special day, a day of national significance, with a ceremonial costume and a photograph of her daughter wearing it: all these things are compressed into the layer upon layer of meaning in this image. An excess of meaning, in fact, just as the many-layered costume itself (a veritable palimpsest of haberdashery – ribbons, handkerchief, petticoats) is immoderate in its protestation of loyalty. It is all too much. The desire, the wanting, the expectation: all that lies behind the attention to, the gaze at, this overfed and undernourished little girl, who surely knows she cannot possibly satisfy such intense need, meet such extreme expectations. And so counter-aggressively, she refuses the gift, disappointing and angering the mother she loves. The costume, despite all the effort, is not quite flawless: its underside betrays itself; the slip is showing.

In this story, the refusal of a gift can also be seen as an act of separation, a declaration on the child's part that she is neither her mother nor her mother's 'inner child'. And yet it is not so simple: for the rejection is equivocal and shot through with guilt, ambivalence, even with a sense of loss. But if the child's defiance is equivocal, she finds herself unable to adopt the less overtly defiant (and more acceptable) strategy of putting on a mask, acting and pleasing like a good little girl whilst maintaining an inward distance from the action. No, she is too involved. Her sullen refusal to

cooperate is a mask of another sort, a cover for contradictory desires. She wants to grow up and be accepted for what she is; but knows that in doing so she risks losing what she prizes above all – her mother's love. If only that love were unconditional, but it is not: it depends upon the child's continuing to mirror the mother's desire, the mother's desire to be the loved and lovable little girl she herself never was and still yearns to be. This is the dilemma facing the awkward-looking child in the photograph: and she is overcome by feelings she cannot name, but which find inchoate expression in her body – in the 'wrong' demeanour, in feeling suffocated.

To this story there is no happy ending, at least in the short term: disappointment is a foregone conclusion. Even if the child accepts the projection and carries on being her mother's baby, in doing so she takes into herself the lack that gave rise to the projection in the first place. She feels incomplete, unable to name her own desires, incapable of following a path that feels her own. She cannot grow up.

Such investments are at work in this as in all my mother's work on my appearance; but in this story there is something else at stake as well. For the dress in the photograph has been made to commemorate a ritual which, being an occasion for national celebration, goes beyond the dynamics of the mother–daughter dyad. On this day, by virtue of the nation's participation in the Coronation, the ordinary, the everyday, will become imbued with the extraordinary, the special. Everyone will be touched by the aura of the event. My dress and the photograph are a tiny part of a grand ceremony of affirmation, of commitment to a larger identity: a sense of national belonging.

Tuesday, June the second, nineteen-fifty-three: a day to remember.

For what seems like weeks, all the houses in Spencer Road, where I live, have been decked out with flags and pictures of the Queen. On the balcony above our ground floor flat there is a larger-than-life portrait of the Queen, wearing a white gown with a blue jewelled sash across her chest. The portrait is framed with ribbons and more flags.

There is to be a tea party for everyone who lives in Spencer Road. Trestle tables and forms have been set up outdoors, on the street outside the pub at the end of the road. The man with the ice-cream stall opposite is going to give all the children one of his special animal-shaped milk ice lollies. We will each be given a Coronation cup and saucer as well.

Among the guests at the Coronation will be Queen Salote of Tonga. Everybody is talking about her, and I see pictures of her in the Daily Mirror.

The Coronation is on television. We are the only people in the street with a television set, which is a Sobell and has a flap that pulls down to cover the screen when it is switched off. Our front room is full of neighbours, friends and relations who have come round to watch the ceremony. The curtains are drawn, and the room is so full of people that the children have to sit on the floor. My mum complains afterwards that my friend Valerie had her hand in her knickers all the time, playing with herself.

At school one day the mayor comes to morning prayers and gives every one of us a silver Coronation spoon.

Aside from the dress, and the photograph which stands as test-ament to its historical existence, these fragments add up to as much as I recall of the Coronation. And yet, such as they are, my recollections are surprisingly similar in content to the popular memory of the Coronation that has been in circulation since the event: the local celebrations, especially the street parties; the Coronation souvenirs; the Queen of Tonga; the television coverage of the occasion. If my memory misses out one thing that everyone else seems to remember – the 'conquest' of Mount Everest by Edmund Hillary and Tensing Norgay, announced on Coronation morning – it adds homelier details like the television set and my friend's improper behaviour in front of it.

Popular memory accounts are marked by the ways in which they bring together the lives of the 'ordinary' people who are its subjects and its producers with events on a grander, more public, scale. Formally speaking, popular memory typically involves the rememberer, the subject, placing herself – what she did or where she was at the time of the big event – at the centre of the scene; as it were grounding the remembered event in her everyday world, domesticating it. For example, I recall the setting and the circum-stances in which I watched the Coronation on television far more vividly than what I saw on the screen; glancingly recollect the feel-ing of being among several hundred schoolchildren at morning assembly on the day the mayor paid his gift-bearing visit; have a fairly strong memory-image of the Coronation decorations in my own street; and can all too readily relive my feelings as I wore the frock that was in its own way part of the decorations. The frag-mentary, anecdotal quality of my recollections is characteristic, as well: popular memory – indeed most memory accounts – unfolds

less as a fully-rounded narrative or drama than as disjointed flash-backs, vignettes, or sketches.

Pointing as it does – in its characteristically local, rooted, immediate, way – to larger, more public histories, popular memory also speaks volumes about the culture and the society in which it is produced and circulated and to which it always alludes. In the case of the Coronation, my own memories – and popular memory in general – of the event invoke key concerns of a particular moment in Britain's postwar history: the promise of a new, more affluent and egalitarian, society; the question of the role of history and tradition in the new order; a reassessment of the idea of Britain as a nation and of the meaning of Britishness.

Among these concerns, a desire to preserve valued national trad-itions in a new, more open, social order assumes paramount significance. Contemporary commentary on the Coronation repeatedly stresses the antiquity of the rite of crowning a British monarch: we are told again and again that the ceremony dates back to the time of William the Conqueror, and that Westminster Abbey has for centuries been the scene of the crowning of English sovereigns. And yet while the ritual of the Coronation ceremony is presented as an ancient, even a timeless, tradition, popular memory of the Coronation of 1953 carries a considerable weight of mean-ings that tie it to a particular historical moment.

In this context, matters having to do with dress and costume assume special significance. In the Coronation service, the Queen undergoes a number of changes of ceremonial dress during the ritual leading up to her anointing and crowning. Within the terms of the liturgy, these transformations are sacramental in the sense that they are outward and visible signs of inner, spiritual

transformations. The Queen arrives at the Abbey wearing an elaborate white gown not unlike a wedding dress, jewels, and a long, sumptuous train. After the first part of the service, the taking of the oath, her ladies-in-waiting divest her of the train and the jewels, and a plain white shift is put on over the dress. After the anointing, the shift is removed and, before the actual moment of crowning, the Queen, with great ceremony, is dressed in a white tunic and invested with a robe of cloth of gold, a stole, and then the crown jewels: orb, ring, rod, sceptre, jewelled gauntlet.

As sacraments representing first the laying bare of the soul preceding contact with the divine, and then the assumption of all of the burdens of monarchy, these transformations of dress lay claim to the timelessness of the sacred. At the same time, though, the promise of spiritual renewal embodied in this sacrament has a special meaning in Britain in 1953, when the austerity of the postwar years was still very much part of people's daily lives. On this less exalted level, the Queen's ceremonial dress and its various transformations stand for change and renewal of more wordly kinds.

The promise is that after the serious business of war and postwar reconstruction the nation, building upon its cultural heritage, will soon enter an era of revival, innovation, plenty and even jollity: the notion much touted at the time of a 'new Elizabethan age' neatly sums up the vision of the old blending happily with the new in an ebullient latter-day Merrie England. Against this background, the pageantry of ceremonial dress – not just the Queen's, but that of the ladies-in-waiting, officiating archbishops, heralds, peers and assorted dignitaries present in Westminster Abbey – offers a sensational spectacle, filling the eye with a vision of abundance. No more self-denial and 'making do'. By 1953, clothing had been 'off

the ration' for several years: though even if in theory people were now free to buy whatever clothes they could afford, the choice of goods available in the shops was still limited; while basic necessities, like meat, were to remain on the ration for at least another year. In 1953, the age of austerity was not quite done with; but the thousands of colourful costumes on display in the Coronation ceremony proclaimed with utter conviction that it very soon would be.

The promise of affluence, gaiety and national renewal is present, too, in the countless imitations of the Coronation's various forms of ceremonial dress, my own among them, in popular celebrations of the event. Contemporary commentators note that a great deal of of dressing up was involved in these festivities; and photographic evidence lends support to this observation. Local celebrations were the occasion of countless costumed re-enactments of the Coronation ceremony.

A photograph of a typical street party in an unnamed location catches the local vicar in the act of crowning a young woman in her early teens. Enthroned with full regalia, she is flanked by several bridesmaid-like ladies-in-waiting. This crowning ceremony is a *vulgarisation* of the Coronation: not in the sense of debasing it, but rather of expressing as folk ritual the common people's sense that the event is theirs too – that it is a part of collective life and so belongs to everyone. The altar-like table in the immediate foreground of the picture, spread with a spotless white cloth and bearing flags, flowers and plates of food, points up the sacramental side of this vulgarisation. The occasion is at once a solemn ritual observance and a party to which everyone is invited. There is a utopian quality to this demotic revelry, a timelessness in its celebration of abundance and fellowship. For a brief moment, the lives of ordinary

people are transformed as they draw the lofty ceremonial of a royal occasion into the familiar space of street and neighbourhood – and so make it part of themselves, and themselves part of it.

The ceremonial dressing up, the 'vulgar' rituals, the local festivities, the plentiful food prepared and consumed collectively: all figure prominently in British popular memory and popular representations of the Coronation, and point to the peculiar blending of high and low, transcendent and mundane, that marks these celebrations and the way they are remembered. Writing soon after the event, sociologists Edward Shils and Michael Young draw attention to the orgiastic quality of the Coronation revelries, and suggest

that the widespread adornment of houses and public places was a sacrificial offering. Their contention is that popular participation in the Coronation, as an occasion for affirming the moral values of a community (in this case the values of an entire nation), has about it many of the qualities of folk religious observance.

But if this ethnographic reading of ordinary people's enthusiasm for the Coronation captures its spirit of reverence, it misses the sheer fun, the 'vulgarity', of the festivities: many people remember the Coronation as one big party. In carnivalesque manner, the people's revels mix high with low, sacred with profane, lofty with vulgar, in a fusion which releases new energy and vitality. Unlike carnival, though, there is neither mockery of nor disrespect for the 'high' here. Rather, the high is joyfully and and devoutly incorporated into the low. Asked to explain why they had put so much effort into decorating houses and streets for the occasion, people tended to respond in terms which might at first sight seem superficial: 'to brighten things up'; 'to make it a bit gay'. But this, surely, is exactly the point: to forget your worries, transform routine dullness and drabness into something special, and revel in this moment with your friends and neighbours.

In memory at least, it seems, popular experience of the Coronation was collective rather than individual or even strictly familial. My own recollections of the Coronation certainly have a marked communitarian mood. My memory has the little Annette, one of the common people of the ethnographic account, receiving the gift of the silver Coronation spoon as just one among several hundred schoolchildren; and the ice lolly and the Coronation cup and saucer as one of the children who happened to live in a particular street. And my recollection of watching the Coronation

ceremony on television has to do more with the room, its furnishings, the other people present and what they were doing than with anything I might have seen of the television coverage itself. Contemporary commentary indicates that, notwithstanding variations in enthusiasm in different social classes and regions of the country, most of the British population was drawn into the spirit of shared celebration. There is also a suggestion that many were taken by surprise by the intensity of the emotions this aroused. (A Mass-Observer reports the words of a dismayed onlooker in the crowd watching the Coronation procession: 'I was astonished at the intensity of my feelings . . . it's against my principles to feel like that'.) Some sort of transcendence of the ego boundaries of rational individuals is apparent in grassroots participation in the ritual and ceremony of the Coronation. Ernest Jones's comments on the psychology of constitutional monarchy are perhaps apposite:

> In the august stateliness and ceremonial pomp [the people's] secret daydreams are at last gratified, and for a moment they are released from the inevitable sordidness and harassing exigencies of mundane existence.

In accounts of the 1953 Coronation, in 'official' histories as well as in popular memory, television always takes centre stage: conventional wisdom has it that the BBC's coverage of the event marked a turning point in the medium's acceptance as part of the nation's life. In 1950, there were no more than a few tens of thousands of television sets in Britain; by Coronation Day, however, the figure had risen to two million. More than twenty million people, 56 per cent of the population, watched the proceedings on television.

Every television receiver in the land, then, was watched by an average of about ten people on Coronation Day.

The crowded room of my memory is clearly far from untypical. Memories of television watching on Coronation Day as a shared activity sit well with these observations: on this day at least, television sets did not belong to individual families or households, but were neighbourhood resources. As the historical account would have it, the people who jammed themselves into our front room to watch the Coronation on the family Sobell were witnesses to the birth of civic ritual as a mass mediated spectacle. Television coverage was represented at the time as offering everyone in the land the right not just to be present, but to have a ringside seat, at a ceremony of great symbolic significance to the nation. Along with the inclusive participation came the visible immediacy that only television could offer: we would be seeing each moment of the ceremony exactly as it was taking place.

And what the nation saw was a piece of public theatre, a pageant. Along with the outright lavishness of the spectacle and the panoramic view offered by the 'window on the world' comes a considerably bigger undertaking: television would bring into our homes images of goods and lifestyles that we would soon be able to enjoy for ourselves. In June 1953, Britain had yet to see its first postwar consumer boom; but everyone was certain it was on the horizon. Television was to play an important part in it. The BBC's efforts to ensure that as many people as possible saw as much of the Coronation as possible on television involved some self-interest, since one of the Corporation's objectives was to make the new medium a key part of the daily life of an affluent – that is to say, a television-owning – nation. But the inclusiveness, presence, visibility

and immediacy offered by television coverage of the Coronation represents a populist moment, too, an expression of a revitalised democracy founded on universal participation in social and national renewal. For the time being, the postwar consensus would hold together the collective aspiration and the promise of affluence. In commemorating feelings of communion and abundance, popular memory of the Coronation does exactly the same.

Being comprised of stories people tell each other about the past, *their* past, popular memory is a shared story, a story visible in the creation in people's talk about the Coronation at the time of the event. It seems that television figured prominently in the countless conversations in which people told each other what they had seen of the ceremony. Of especially compelling interest was one of the Queen's guests at the Coronation ceremony, Salote, Queen of Tonga. But why does the ruler of a Polynesian island few in Britain had even heard of before the Coronation have such a stellar role in popular memory of the event? And why does she figure in the way she does? Three stories about Salote were repeatedly retold around the time of the Coronation, and are still in circulation. First, the simple observation, or the assumption, that she was immensely popular ('Linger longer, Queen of Tonga/Linger longer, do', she was urged). Second, that Salote alone braved the heavy rain that fell on the Coronation procession to wave to the crowds from an open carriage. Third, a joke:

Q: Who is the little man sitting in the carriage with Queen Salote?

A: Her lunch.

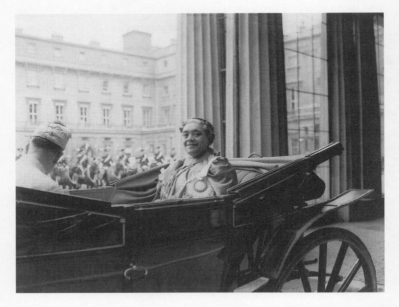

'The tallest queen in the world (6ft 3in in height) . . . repeatedly waved and smiled to the crowds, completely ignoring the heavy rain which was falling'

Of a large contingent of Commonwealth heads of state invited to Britain to attend the Coronation, Salote was singled out for unique attention and adulation. 'The tallest queen in the world' is represented as a larger-than-life figure in other ways, too, for it seems that she dwarfs, and is even capable of devouring, her carriage companion. Generosity and permission-giving are the hallmarks of the persona of Salote, who becomes a sort of mistress

of the revels. And yet she also possesses considerable dignity, figuring in the popular imagination very much as a powerful matriarch.

As the reigning monarch of Tonga for thirty-five years and, aside from Elizabeth, the only queen in the Commonwealth, Salote is ideally cast in a piece of theatre featuring a symbolic meeting of two queens. The ampleness, bonhomie, maturity of experience and dark complexion of the one supply the perfect foil to the youth, inexperience, solemnity, diminutiveness and whiteness of the other. Salote is what Elizabeth, at twenty-seven, is not – or not yet. She is in a sense also what Elizabeth will one day become: a female sovereign of ripe years and in possession of considerable matriarchal authority. Photographs of Salote suggest a certain resemblance in bearing to the older Queen Victoria (the younger of the two queens was more explicitly – and less convincingly – likened to the first Queen Elizabeth). Alongside Salote, the Elizabeth of 1953 emerges with singular force as a figure for youth and energy and for the lofty ideals behind the quest for national renewal. But as queen of the people's revels, Salote brings things down to earth a little, bridging the gap between high and low, easing the intermingling of sacred and profane, seriousness and laughter, in 'vulgar' celebrations of the Coronation.

The web of fantasy surrounding the persona of the Queen of Tonga must account in some measure for the apparently genuine affection in which she was held by the British people. And yet there is surely more to it than this. What, for example, are we to make of the fact that this persona has about it more than a shade of the monstrous, devouring mother? Salote's island domain is still, in 1953, a tiny blob of pink on the world map, and Salote herself in some ways recalls Victoria, the sovereign matriarch who presided

over the British Empire at its zenith. Does Salote not stand for the presence at the Coronation of a formerly mighty but now crumbling Empire? If Salote is associated with an erstwhile imperial age, Elizabeth stands for a certain post-imperial order. The British Empire's benign successor, the Commonwealth of Nations, is constructed very much as a *family*, a family of nations. As head of this family, Elizabeth in 1953 is regarded as a sort of apprentice *materfamilias*, the dutiful and caring young mother of a family whose junior members will in due time grow up and make their own way in the world, keeping up family ties; and whose senior members will stem any unruly behaviour on the youngsters' part.

The family motif at the heart of the idea of the Commonwealth thoroughly imbues representations and memories of the Coronation, such that Coronation and Commonwealth are inextricably linked in the popular imagination. This is clearest, perhaps, in the idea of the Royal Family itself. Like any other family, the Royal Family is at once real (with its own quota of shadows, secrets and black sheep; most obviously here in the person of the unmentionably absent Duke of Windsor, who watched the proceedings on television in Paris) and a repository of innumerable fantasies fuelled by desire for unconditional love, intimacy, closeness, security. As the mother of two young children, the Queen readily serves as a figure of popular identification; and yet as sovereign she stands at many removes from the lives of ordinary citizens. But the royalness of this particular family – the specific combination of similarity to and difference from the rest of us – writes these fantasies peculiarly large. In the Royal Family, the family is imagined in its most idealised form.

Perhaps the most widely circulated photograph from

'A Coronation Day picture for the Royal Family album'

Coronation Day shows the Queen and the Duke of Edinburgh with their children, along with relatives and attendants, arranged as a family group on the balcony of Buckingham Palace after the ceremony, waving to the crowds below. Like the 'Royal Family album' photograph, it is reminiscent in style of the conventional formal wedding group photograph, if rather grander in scale and setting than most people's wedding pictures. Such images speak with eloquence of the distinctive mix of ordinary and extraordinary, ideal and real, present in popular representations of the Royal Family around the time of the Coronation.

While serving as mirror and model for ordinary families, the Royal Family also epitomises and celebrates not only the ties that bind together all people who belong to one nation, but also the ties between nations: the nation *as* family; the family *of* nations. In this topos, in which she figures most prominently as a mother figure, the sovereign's femaleness is all-important. Salote, older Queen and benevolent matriarch of another island nation, but junior member of the family of nations, reinforces what Elizabeth, the younger but in the end the more powerful woman, represents for the British nation and the Commonwealth. The family/nation/Commonwealth nexus also connects with the Coronation's historical meanings, in the suggestion that the promised better future will be carried forward with a respect for cherished traditions. As part of Britain's past, the Empire is to be neither forgotten nor jettisoned, but will transform itself into an internally harmonious and mutually supportive family of nations.

The Coronation service in Westminster Abbey was attended by ruling figures from all over the Commonwealth; and the Coronation procession included thousands of members of

Commonwealth police and armed forces, all of whom received considerable attention in media coverage of the event. Such a gathering would never again take place in Britain: the Coronation was a swansong, perhaps the very day the sun set at last on the British Empire. In her dignified and reassuring matronliness, Queen Salote bridges the old Empire and the new Commonwealth, easing the passage into decline, making it acceptable, even perhaps noble.

In these imaginings of monarchy and family, nation and Empire, Salote and Elizabeth are indivisible, two sides of a single coin in a currency that still retains its value in the 'mother' country. Not only does the *idea* of the mother carry considerable force here; the matriarchal power of flesh-and-blood women reigns supreme as well. The queen, birth mother of her own children and ruler of the mother country, is mother also to the nation as family and the family of nations.

And yet there is a darker underside to these homely imaginings. The 'Royal Family Album' photograph is completely dominated by women, royal males being relegated to the edges of the frame and the back of the group. Is there not a hint of excess in this frank representation of the dominance of matriarchs within a pre-eminently powerful family? And, like the powerful mother of archetype, the high-profile Salote has a terrible aspect that is more than merely hinted at in the suggestion of cannibalism in the endlessly repeated joke. Does this suggestion of savagery, a murky side of an otherwise reassuring presence, not presage cracks in the harmonious relations within the nation as family and the family of nations? After all Salote, the dark queen, stands for those parts of the Empire that would soon be dubbed the 'new' Commonwealth, a euphemistic

reference to the Commonwealth's non-white member countries.

For while the Commonwealth's ruling elites – black, brown, and white – were making their brief visit 'home' as the Queen's invited guests at her Coronation, the Empire – in the form of hundreds of thousands of economic migrants from the new Commonwealth – was making a less temporary return to the shores of the mother country. Having launched themselves on the migrant's eternal quest for better lives for themselves and their children, these humbler Commonwealth citizens would, unlike the Queen of Tonga, decidedly linger longer.

Organised as a multicultural and multiracial event, the Coronation provided the occasion for an affirmation of kinship between the people of Britain and the people of the Commonwealth. But this was a kinship that depended upon geographical separation. As the solitary suggestion of ethnic difference in British popular memory of the Coronation, Salote emerges in the sharpest relief, standing not only for the qualified kinship of outward relations between Commonwealth and mother country, but also for the repression of ethnic difference that is required in order to sustain those ties.

If the permanent presence in Britain of black and brown Commonwealth citizens would eventually come to be seen as a social problem, it would also bring with it the potential for a revitalisation of the idea of Britishness which has little to do with the particular promise of national renewal embodied in the Coronation. But all this was yet to come: in 1953, the genuinely warm welcome extended to Salote notwithstanding, to be British was still to inhabit that default ethnic identity: white.

All this suggests that the idea of the British – and perhaps of any

other – nation as a family is founded on repressions. The Empire's unheralded return to Britain, erasing the lines of distinction between the nation as family and the family of nations, was eventually to force some of these into the open. Meanwhile, though, the consequences of the Empire's eclipse were certainly not anticipated in that brave future envisioned on Tuesday, June the second, nineteen-fifty-three.

What does all this have to do with a photograph of a little girl in white, a little girl in a dress made specially for the Coronation? Both scenes – the larger one of popular memory of the Coronation and its social and cultural significance; the smaller one of my own memories, the Coronation frock, and the photograph – are packed with layer upon layer of cultural and psychical meaning. Both also involve family dramas of one sort or another. And in the manner of such dramas, both scenes give expression to the desire, the power, we invest in the idea of the family as a safe haven; while yet exposing the impossibility of that ideal.

'The country and the Commonwealth last Tuesday were not far from the Kingdom of Heaven', the Archbishop of Canterbury is reported to have said soon after Coronation Day. Hyberbole it might be, but this statement does give expression to something of the spirit of the Coronation voiced in contemporary accounts, and resurfacing in popular memory, of the occasion. What comes across most strongly in these is both a sense of community and an almost transcendent aspiration to communion. What the Archbishop did not add, though, was that the Kingdom of Heaven visited for a day by the ordinary people of Britain who celebrated the Coronation with communal television-watching, imitation

crownings, parties and dancing in the streets was also a place of laughter, gaiety and release, a land of Cockaigne where, just for a day, you could let yourself go and have a wonderful time.

Notwithstanding, the communal and communitarian quality – transcendent or mundane, high or low – of representations and memories of the Coronation is founded on a certain idea of the family and of the place of the mother, or maternal power, within the family. But closer scrutiny of these representations and memories – a look at what is not shown, not remembered, and also at the deeper meanings, the shadow sides, of what *is* shown and remembered, brings to light some family secrets.

In the smaller story, the little girl's frock and its commemoration in a photograph can be read both as a statement of attachment – to a community, a nation – through participation in a ritual; and also as visible expression of an Oedipal drama that is both personal (its cast of very ordinary characters consisting of myself and my immediate family) and collective (the feeling tone, if not the detail, of the story will undoubtedly strike a chord of recognition in others). The ritual meaning of her costume was no doubt largely lost on a young Annette wholly preoccupied by her loathing of the outfit and her discomfort about wearing it. But this in no way detracts from the broader symbolic and cultural meaning of a child dressed up and put on display in this manner.

The sense that life surely ought to be better, at least once in a while, for ordinary working people translates itself in the special circumstances of the Coronation into a desire for belonging, for attachment to larger ties: community, nation, Empire. However, as an expression of my mother's yearning for something better, something she had never had, the Coronation dress writes small these

imagined communities, colouring them with the hues of a particular psyche and a personal history. The corollary of this must be the flipside of every Oedipal drama: projection, hostility, and disillusion ensue as reality inevitably falls short of the ideal. The loyalty, the wish to belong, claimed in the outward display of a ceremonial dress and a photograph of it are riven with disenchantment: a daughter disappoints, an Empire crumbles.

This, perhaps, is the point of connection between a mother–daughter drama and a national occasion. If my stories about Coronation Day, the dress and the photograph underline the impossibility of the family as an ideal, they also point up the difficulty of an imagined community of nationhood that takes the family as its model. While it might be possible, even necessary, to understand – indeed to live and try to hold on to – the utopian desire that fuels these ideals, is it not incumbent on us to direct it into a quest for attachments that do not rest on repressions?

6

Passing

At the age of eleven, I passed the eleven-plus examination and won a place at a grammar school. I sat the examination at the primary school I had been attending since I was eight, when my parents and I had moved from our flat in Chiswick to a two-up, two-down former railway workers' terraced house some miles outside London.

Leaving my first home had been an unpleasant shock. If the move was in some respects a going down in the world for the three of us, there was something far deeper at stake as far as I was concerned: a loss of innocence. Perhaps a sense of falling from grace is a common childhood experience: you reach the age of reason and start taking critical note of the world around, perceive disenchanting imperfections in the ones you love, and nothing is ever the same again. Perhaps I was told the grownups' reasons for the move, though I think not. If I was, they were probably beyond my understanding; or possibly, in the egotistical manner of the child, I did not particularly trouble myself with them. And yet in retrospect I sense that whatever might have prompted it, the move coincided with some decisive change in my parents' relationship.

Our move into what was in effect my mother's territory (my granny and my mother's youngest brother and his family had rented the house before we came; several aunts and cousins lived close by; and both my own brothers, with their families, were later to move into the same street) coincided with a deterioration in my father's health and a marked withdrawal on his part from the life of the household. It soon became clear that he no longer counted for much. My mother, caught up more deeply than ever in the affairs of the extended family, and always working full-time, had little time or emotional energy to give her daughter.

Left to my own devices to find a niche in these new surroundings, a world much tougher than the one I had been used to, I learned to speak with coarser accents, to shoplift, and to contrive strategies for survival in a school where more energy was devoted to bullying, in and out of the classroom, than to teaching and learning.

And yet the neglect did have its positive side. I enjoyed considerable freedom to roam the streets, waste grounds, disused railway tracks, allotments, and fields of the neighbourhood, ducking unannounced in and out of the houses of friends, neighbours and relations. For days on end, it seems in recollection, I could escape notice and avoid unwelcome attention to my rapidly deteriorating appearance and manners. During school holidays I was sent for weeks at a time to stay with various aunts. Once the inevitable homesickness was out of the way, this always turned out to be a treat, certainly in comparison with life at home.

After three years of bad schooling and parental disregard, my passing the 11-plus was perhaps in some ways a surprise. From a huge extended family, I was only the second child to receive a selective secondary education (the other was a cousin, the only son

of my Uncle Fred, a self-made man in the building trade who had married 'up'). But then at home, if not at school, there had never been any doubt that whatever else the otherwise unappealing Annette lacked, it was not 'brains'. I had even received the customary reward for 'passing the scholarship' – a new bike – months before the eleven-plus results were due.

The day I cycled home from school bearing the telltale thick brown envelope, I became, for the first time in years, a centre of agreeable attention. My achievement was a source of great pride, especially for my mother. From the list of schools available, she picked the one she herself would have gone to, given the opportunity: a county grammar school for girls in Twickenham, a half-hour bus ride from home. If with hindsight this was not the best possible choice, it was far from the worst. I was especially relieved, after the rigours of a mixed primary school, to be going to a single-sex secondary school.

The compulsory school uniform consisted of complete outfits for summer and winter, including different hats, coats and shoes for each season, with additional kit for gym, sports, and laboratory work, all in the regulation school colours and styles. Because of the considerable cost of all these clothes, every possible item of uniform was bought several sizes too large for me, so that it would last. Maternal pride saw to it that a photograph was taken of me wearing the newly-acquired outfit, which swamped me: I looked and felt like a refugee dressed in someone else's clothes. On the morning I left the house in this brand-new, vastly oversized, gear to face my first day at the grammar school I had not the slightest idea what to expect.

If the world that greeted me there seemed at first bewilderingly

alien and chaotic, I soon came to grasp the order underlying the outward confusion, the most immediate manifestation of which was streaming. On that first day, new pupils were divided according to ability as measured by their 11-plus scores, and put into four groups. I was directed into the top (A) stream, where I was to stay throughout my school career. Movement between streams was rare: while the 11-plus score might not have been an impeccable predictor of intellectual ability, it certainly became a self-fulfilling prophecy (if you're told you are clever or dull, you will perform accordingly). From day one, every new girl was fully aware of her place in the school's scheme of things.

On the whole, too, the rules of the school were quite clear. If you observed them reasonably closely and performed well academically, you could succeed at a certain, highly valued, level. Since I was willing to go along with the rules and able, without too much effort, to do the work, the academic side of my grammar school career presented few problems. My time there was also remarkably free of the petty humiliations that had been routine at my primary school. But if grammar school turned out to be the very opposite of chaotic, it never ceased feeling strange to me, and I always felt an outsider there.

For although brains, sticking to the rules, doing well academically and passing exams went a long way, they were not, as it turned out, quite the sum total of what was required. In fact, on their own these qualities might even be regarded as slightly suspect, the plodding literal-mindedness of the swot. No, the extra something was subtler than anything explicitly laid down in the school rules, and you either already knew what it was, or else you did not. Whatever it was, this something that I did not know could not be got through

the habitual strategies of more-or-less good behaviour, study and passing exams. I see today what I could not see then: that, as part of its predominantly petit bourgeois system of values, the school took for granted a certain 'cultural capital' in its pupils. The cornerstone of the school's value system was its insistence on a rigid demarcation between 'us' and 'them': 'us' being the elect, the few chosen for selective secondary education, as against the rest, 'them', the *hoi polloi*, the uncouth and brainless masses beyond the school walls.

As for its academic – as opposed to its social – agenda, within an overall bias in favour of humanities subjects, the school set its highest value on disciplines and ways of knowing grounded in cognitive as against creative skills (subjects like art and music were for the C-streamers) and a meticulous approach to the task at hand rather than a passionate engagement in it. Diligently acquired and applied cognitive abilities paid the highest dividends at exam time. Grammar school pupils were perpetually faced with hurdles, which took the form mainly of public examinations. Once you had negotiated one, there was always another a little way along the track. If you could just keep yourself moving and jump each hurdle as it presented itself, school life acquired its own momentum. You could slip into the flow and be carried along, never called upon to exercise any will of your own.

The girls' grammar school's preferred subject areas, styles of learning, goals and methods of achieving them were not on the whole conducive to the development of initiative or creativity. Consistency, industriousness, good behaviour, neatness, ability to perform well in examinations: all of these qualities suggest a dutiful and instrumental approach to learning and a shying away from

untidy, unpredictable and above all, unladylike, fervour. For pupils prepared to accept these terms, grammar school offered considerable security and the assurance that you would come away with something tangible and useful to show for the years of keeping on track: paper qualifications, valued so highly in the world outside. Others were less fortunate, for the scrapheap was not reserved solely for 'them'. Grammar school pupils who strayed from the track could find themselves on it as well. Even the ones who managed to stay in the academic race could quite easily find themselves at odds with other aspects of the school's culture, most especially with the unwritten codes of its social agenda.

Because the school's social class values were so ingrained, it was impossible to give a name to my own feeling of not belonging. If certain things about being at school felt uncomfortable, the problem, I thought, must lie with me. It was surely my own fault if I did not fit in: there were obviously some rules somewhere that I had failed to grasp. No-one, as far as I remember, ever made fun of my accent or of my not-quite-right uniform. On the contrary, teachers and fellow-pupils behaved with a niceness that can only be described as relentless: it had about it a cool, detached, numbing quality that left you feeling as if you did not quite exist. I knew very well that I was not one of them (which meant, of course, that I was not one of 'us', either); and that my difference was something to be ashamed of. I soon learned to keep much of myself and my life hidden from view, staying quiet about things that really mattered, drawing firm boundaries between life inside and outside school.

But life at home was not exactly a model of warmth and mutual caring, either. Many things changed when I went to my new school: with homework to do, there was less freedom to roam outdoors. I

lost touch, albeit with few regrets, with friends from my former school. Social life centred more and more on my mother's family, and it was through my mother that I met the best friend of my teenage years, a local secondary modern schoolgirl. Quite soon, my being at grammar school ceased being a source of pride and began to be a bone of contention. The things I was learning – Latin, French, Maths – were already far beyond the range of my parents' elementary school education; and, for my mother certainly, this was difficult to cope with: was Annette becoming a snob? And if my father seemed more supportive, this probably had as much to do with the war going on between himself and my mother as with any pressing concern for his daughter's welfare.

For by the time I was thirteen or so, the family was seriously dysfunctional. My father, sick and marginalised, was little more than a spectral physical presence in the house: I knew quite well where the real power lay, and behaved accordingly. My mother, now in her fifties and working long hours in the workmen's cafe she owned, was touchy, ill-tempered, and resentful of her daughter. The closeness between us was still there; but it had assumed a stifling, conflicted, unpredictable – *unsafe* – quality whose feeling-tone I still shudder to recall. School became the focus for everything that was amiss between us. She would denounce my newly-acquired 'book learning' as useless for survival in the real world. I was squandering my time, especially since (she said) education is completely wasted on a girl: she'll only get married.

If I now recognise something of the pain behind my mother's oft-repeated tirades – there was a good deal of angry shouting, as I recall – at the age of thirteen or fourteen, powerless and dependent, I was simply scared by them. When I reached minimum

school-leaving age, the diatribe notched itself into a higher gear and new rebukes were added: 'You're leaving that school!'; 'You can't rise out of your class'. I was chilled to the marrow. The last thing I wanted was to leave school without completing the course. And if rising out of my class might not have been what I thought I was about, the idea of its being something you simply could not do had about it the air of a prison door slamming.

I longed for my mother's approval for what I was, for what I might become, even if this was not going to be what she had been. But I had little idea how to please her, and rarely seemed to put a foot right. Small wonder, then, that by comparison with the end-lessly shifting goalposts of my home life, school, with its mostly unambiguous rules and predictable ways of getting by, felt a safe haven, even if not always a comfortable one. In the end, though, I did not complete the full seven years at grammar school, because at the start of the first year of sixth form I was turned out of home. With the help of a grant from a charitable trust, I completed the school year and, being on the A stream fast track, left, after six years, in possession of two GCE A levels.

In all those years, I had never quite succeeded in falling in line with the school's social class agenda. I was among a small minority of girls in the sixth form who was not made a prefect; and in a mock general election, presumably intended as a lesson in civic responsibility, and in which the Tories scored a landslide victory, the Liberal Party netted more of my schoolmates' votes than Labour, which limped in at an undignified and unrepresentative third place, mine being among the handful of covertly defiant votes it had managed to attract. During my last two years at school, I was also preoccupied with an extracurricular social life which combined

the more or less respectable (church youth club) with the mildly *outré* (R & B music fandom) and a distracting infatuation with my first real boyfriend.

Although anything smacking of an interest in popular culture or sex was frowned upon there, at a certain point the school was obliged to face the fact that it was dealing not with disembodied minds but with young women. While its academic agenda assumed – or hoped for – a certain androgynous unworldliness on its pupils' part, its aspirations for their lives beyond school were severely hamstrung by gender stereotypes. Of the girls who stayed on track to jump the final hurdles, a handful might go on to university as a prelude to schoolteaching. Most of the rest would enter teacher or nursing training, the assumption being that for those who did not end up as teachers or nurses (and very remotely possibly also some who did) this training would help them become 'reliable mothers and serious-minded organisers of voluntary organisations'. If at this point I was uncertain what I wanted to do with my life, the prospect of being a pillar of the community did not exactly stir the imagination: surely there ought to be more to life than a choice between bourgeois matronhood and a roomful of schoolchildren?

From my six years at grammar school I recall with the greatest clarity the supreme importance attaching to the school uniform. In my memory, it stands on the one hand for the security and the alienness of school life, and on the other for the first flush of pride and the subsequent bitter conflict at home around my schooling. Sadly, the photograph of me in my newly-bought uniform is lost now, but I retain a clear sense not just of what the

picture looked like but also of how it felt to be inside those clothes at that moment. I did not particularly like the photograph: to me, the girl in the too-big uniform looked fat, graceless and out of place. What was there to be proud of? Did the sleeves of the blazer cover my limply hanging hands, as my memory-image insists? Were its shoulder seams several inches past my drooping shoulders? Was the hem of the dress six inches below my knees? Did strands of badly-cut hair stick out from underneath the awkwardly-placed beret? These clothes, in every sense, decidedly did not fit.

And yet this uniform was proof for all to see that, as an eleven-year-old bound for a good school, I was different, cleverer, a cut above the rest: it singled me out from the rest of my contemporaries. The fact that the photograph was made at all is proof that, for a brief time at least, I was once again special, the credit to my mother I had stopped being several years earlier: the photograph was her own idea, and she went to some trouble to arrange it. But these clothes were more than simply a mark of the eleven-year-old Annette's superiority: my mother undoubtedly had investments of her own in them. Through them, perhaps, she might relive an earlier time, when attention to her daughter's appearance had been pleasurable and rewarding. Perhaps in this uniform she saw what she might have been had life been kinder to her. Did the occasion evoke an older and deeper fascination, too, a fascination with uniforms born of longing for an absent soldier father? Whatever lay behind my mother's preoccupation with my school uniform, one of its consequences was her willingness to bear the considerable cost of kitting me out with all the regulation gear. This she did without, as I recall, seeking financial assistance

(local education authority grants were available for this purpose), nor even grumbling.

As visible evidence of cash expended, the grammar school uniform reinforced the class agenda underlying its us/them division. In excluding outsiders, the uniform subsumed the individuality of the insiders to the whole, to the school as an organisation. To wear the school's uniform was to subordinate yourself to the organisation and its rules. Pupils both represented, and became identified with, the school. Hence the proliferation of school uniform rules: berets and boaters were to be worn on top of the head (with no back-combing of the hair or pert angling of the headgear); no jewellery, apart from wristwatches, was allowed; hats were to be worn at all times when in uniform off school premises; the hem of gym shorts was to be no higher than four finger-widths above the knee; and so on, and so on.

Many of the uniform rules at my single-sex school were gender-specific: they made sense only if the uniform's wearer was female. If the uniform (and thus the school) was greater than the individual pupil, for a school*girl* it was the unruly feminine side of her individuality that had most forcibly to be held in check if order were to prevail. In this context, order is equated with a specific model of femininity. The rules for behaviour when wearing uniform outside school – you were supposed always to comport yourself with ladylike decorum – have everything to do with pre-suppositions about the proper conduct in public of young women of a certain class.

The overt rationale for school uniform was that it was a democratic leveller: if everyone wore the same clothes to school, social divisions within the school would be ironed out; and (perhaps more

to the point in terms of the ethos of a girls' grammar school) pupils would not be distracted from their studies by trivial preoccupations with fashion. School uniform was also supposed to be integrative for 'us', fostering *esprit de corps* and loyalty to the school. But in reality things were not always quite so clearcut. If the oversized uniforms sported by some of the new girls would have required neither a semiotician nor a style-conscious teenager to decode, there were numerous ways in which even with the unpromising material of school uniform adolescent girls could and did produce and read the subtlest of distinctions amongst themselves. Other giveaways might be your shoes, say – stout regulation Clarks lace-ups as against more flimsy items from the cheaper high-street chainstores – or the frequency with which outworn items of uniform were replaced.

In all of these areas, I felt conspicuously out of place; perhaps most excruciatingly so because after five or six years, my school uniform still included a good number of items that had been bought for me at the age of eleven. My mother's investment, psychical and financial, in my uniform was clearly shortlived. By the time it fitted me, my school uniform was already shabby. But it remained in service, with one or two replacements, until well beyond the outworn stage. In consequence, one way and another, I never came within a mile of the school's notion of a smart appearance. Luckily, though, since infringement of uniform rules in countless small ways was practically *de rigueur*, being slightly unkempt was not utterly unacceptable within the peer group.

All the same, I knew that the scruffiness I affected with some bravado was really a masquerade, disguise for a more fundamental shabbiness. My clothes did not fit, I was different: and, being born

of inferiority, this difference was the source of the deepest shame, the most craven fear of exposure. Would my cover be blown, and the terrible truth of what I truly was be revealed? Would I be stripped of my shoddy disguise and shown up as an impostor, passing for something I was not?

I found myself in this alien setting by virtue of being one among a generation of children who benefited from changes in the system of state education in England and Wales after World War II. The 1944 Education Act decreed that every child should receive a free secondary education, and that secondary education would be tripartite. At the age of eleven, children would be banded into three groups: those deemed suitable for academically-oriented schooling would go to grammar schools; technical schools would take pupils whose abilities suited them more to the higher levels of vocational education; the rest would go to 'modern' schools. The technical school option failed to materialise in most areas, and by the time I took the 11-plus the alternatives boiled down to grammar for the 'brains' and 'sec mod' for the others. The proportion of all eleven-year-olds obtaining grammar-school places varied from area to area, but was always a minority.

The objective of the 1944 Act was to modify the rigidity of the pre-existing system in which, with the exception of those whose parents could pay for secondary education for their children, or the extremely few poorer children who won scholarships for free places, all children, however bright, received only the most minimal education. The new scheme was to offer not equality (on the contrary, the tripartite system was deeply hierarchical) but equality of opportunity. Because every child would take the 11-plus examination,

every child would also have an opportunity to win a selective secondary education.

This was a definite improvement on previous arrangements. Neither of my parents, though not short of 'brains', was offered even the chance of competing for a scholarship to a secondary school. But if the eleven-plus system did open up hitherto unavailable opportunities, it was still by no means class-neutral. Relatively few children from working-class homes were offered grammar school places: in fact, the odds against these children were high. Of the approximately seventy pupils who entered the eleven-plus exam at my primary school (which, while in a predominantly working-class area, was certainly no 'sink' establishment), perhaps four or five went on to grammar schools.

The class bias of the eleven-plus examination had a predictable impact on the social composition of grammar schools. And the fact that they were attended largely by children from middle-class homes in turn reinforced the ethics and outlook of these schools, their assumptions about pupils' upbringing and cultural capital. It is not surprising that in such a milieu working-class children, already in a minority, should find themselves out of their depth in ways that had nothing whatever to do with their academic ability. 'Brains' were simply not enough to get you by. And since in girls' grammar schools, the middle-class ethos embraced innumerable assumptions about restrained, ladylike behaviour, toughness and native wit did not count for a great deal, either.

In this setting, the working-class 'scholarship girl' was truly an outsider; for the school's value system was likely to be seriously at odds with codes of acceptable behaviour at home or in her neighbourhood. Many such girls, labelled dull and consigned to C or D

streams, would resist the school's ethos, become 'troublemakers', and leave school at the earliest possible opportunity. But for those wishing to take advantage of the education the school offered, many aspects of its value system – perhaps above all the us/them divide – caused difficulty. It meant, for instance, that even if she had spare time after the obligatory homework, the scholarship girl could not mix comfortably with neighbourhood children from the secondary modern school. Aside from anything else, her school uniform set her apart: even the simple act of leaving home in the morning and coming back in the afternoon was a statement of her difference from them.

Caught between two ways of belonging, between milieux which demanded entirely different kinds of conformity, the scholarship girl stood at risk of losing all sense of what she was or might become. An outsider at school, she also lost any easy sense of belonging at home and in her neighbourhood. She learned to cope with feeling out of place wherever she happened to be. At home, perhaps, she revealed little about what was going on at school and avoided bringing school friends to the house. At school, she kept quiet about her other life. By her silence she could avoid betraying herself, could conceal her ignorance of things her schoolmates appeared to take for granted. When she had to speak, she could camouflage her accent by honing a more refined speech for use at school. She could find safety there by staying out of trouble, observing more or less closely the myriad regulations for pupils' conduct, sticking to the school's academic values, and doing well in examinations. She could, in other words, try to pass for something she knew she was not.

Did the chill that struck my heart at my mother's 'You can't rise

out of your class' then stem from a recognition of some simple truth? That the overt meritocratic message of equality of opportunity was perpetually undermined by the subtler agenda of the grammar school's middle-class ethos? At the time, I imagine, I read my mother's pronouncement merely as a statement of the values of a bygone era. Even if it had been true for my mother, it certainly would not be true for me: times had changed. Knowing that my schooling was coming between us, my mother wanted to drag me back into her sphere of influence. And *down*, yes: while I would have died rather than admit it, even to myself, I was not entirely immune from the snobbishness all around me at school, nor untouched by class envy. A large part of me did indeed yearn for the apparently easy birthright of my classmates.

The alternative my mother offered, and what she represented – familiarity, yes; but frustration, resentment, a home life in which happiness and warmth were, if not absent, intermittent and unreliable – was not, as far as I could see, a viable option. As much as any wish to 'better myself', my desperate clinging to school was born of a terror of being pulled back into that pit. Had things not been so difficult at home, I might well have given up on school sooner than I did.

There are many crosscurrents here: the pull of being, in my school's terms, a good learner and academic performer; the push of its class ethos; the pull of the familiar; the push of a deeply conflicted home. If in the end, in a situation in which I was powerless to act, fate took a hand, it was to be at the cost of abandoning my roots. Such a thing is achieved only at a cost. Today, feeling safer, I can look again at 'You can't rise out of your class' and see in it a message less negative than the one I saw as a teenager.

When the sociologists Brian Jackson and Dennis Marsden talked to a group of adults who had gone to grammar schools from working-class homes, they were surprised to find that many of these people, by now in professional and managerial jobs, claimed still to be working class. An insightful explanation is offered:

> 'class' could be something in the blood, in the very fibre of a man or woman: a way of growing, feeling, judging, taken out of the resources of generations gone before.

Chimera or not, the meritocratic ideal of equality of opportunity would have us forget this, would have us believe that by virtue of getting an education a working-class child becomes something else; that you cannot be working-class and at the same time be educated and civilised.

Like many scholarship boys and girls before and after me, I discovered, on the pulse, that it is not quite so easy: you cannot lightly shed everything that has gone into your formation when you don the uniform of a 'good school'. You learn, through messages that are none the less forceful for being unspoken, that your clothes don't quite fit, that your voice doesn't quite ring true, that you don't belong. For survival's sake, you can acquire a veneer of refinement, learn to keep quiet about what really matters to you, lower your sights, keep your ambitions modest. But then you risk forgetting the value of those 'resources of generations gone before' that might still be there inside you, in spite of everything: your resilience, your courage, your capacity for endurance, your quick wit; your ready sense of the ironic, your ability to feel.

You can so easily internalise the judgements of a different

culture and believe – no, *know* – that there is something shameful and wrong about you, that you are inarticulate and stupid, have nothing to say of any value or importance, that no-one will listen to you in any case, that you are undeserving, unentitled, cannot think properly, are incapable of 'getting it right'. You know that if you pretend to be something else, if you try to act as if you were one of the entitled, you risk exposure and humiliation. And you learn that these feelings may return to haunt you for the rest of your life.

Class is not just about the way you talk, or dress, or furnish your home; it is not just about the job you do or how much money you make doing it; nor is it merely about whether or not you have A levels or went to university, nor which university you went to. Class is something beneath your clothes, under your skin, in your reflexes, in your psyche, at the very core of your being. In the all-encompassing English class system, if you know that you are in the 'wrong' class, you know that therefore you are a valueless person. Working-class children of my generation who, against the odds, got a selective secondary education learned this lesson every time they put on their grammar school uniforms. The price they were asked to pay for their education was amnesia, a sense of being uprooted – and above all, perhaps, a loss of authenticity, an inability to draw on the wisdom, strengths and resources of their roots to forge their own paths to adulthood.

Nobody, of course, intended that the grammar school system should be so devastatingly costly to the self-esteem of some of its pupils. Indeed, as a bright schoolgirl, I received nothing but encouragement from my teachers; and when the family crisis blew up so spectacularly that there was nothing for it but to make it known at

school, their support was as solid as it was blessedly discreet. And I did leave with qualifications which were to open doors, and an educational grounding that has proved its worth time and time again. None the less school was well behind me before I could launch myself on what I regard as my true education – for which, ironically enough, I was to make good use of the tools with which grammar school had equipped me.

In my first job, as an assistant in an inner-city Central Public Library, a storehouse of learning lay at my disposal; and during long commutes and between many split shifts, I embarked on a programme of reading that was none the less instructive for being entirely haphazard: it ranged from Françoise Sagan (in French) through the partition of Poland (my closest friend at the library was the daughter of Polish immigrants) to jurisprudence and toxicology (from books full of gory pictures of diseased and wounded flesh which for some reason were shelved in the staff tea room). A couple of years later, hospitalised after a serious road accident and with plenty of time on my hands, my reading began to acquire some direction. I happened upon – I no longer remember how – books that fed my intellect and fired my imagination in entirely new ways: *Discrimination and Popular Culture*, *The Popular Arts*, and above all, *The Uses of Literacy*.

What engaged me most of all about these was that they were serious works about things that mattered to me, things I had never before seen treated as in any way consequential; things that belonged to the secret lives I had been so ashamed of at school. Using the language and the ways of knowing I had encountered at school – book learning, in other words – they explored questions that had decidedly not been the legitimate stuff of the school

curriculum: popular media and culture, the very sorts of activities 'they' would fecklessly indulge in. Above all, Richard Hoggart's account of popular culture and the working class touched me, for the first time in my life, with a profound recognition of something shared but previously unnamed. My own life was being described as if it merited serious scholarly attention.

Given that the working-class life described in *The Uses of Literacy* (which had been written in the early 1950s) was essentially that of the north of England in the years before and just after World War II, such an engaged sense of recognition on the part of a young woman living in the London of the swinging sixties might seem a little odd. But aside from its serious treatment of matters of vital concern to me – this was the first time, for example, that I had even seen class *named* in this way – there was something about the way this book was written that moved me deeply. I saw that it spoke in some way from inside its subject matter: Hoggart could name my experience not because his was the same as mine (it clearly was not), but because we shared a common stance in relation to it.

We were both distanced, but engaged, observers of something meaningful that we had left behind, if not quite lost. We shared the clarity of vision of the outsider who understands, because she or he has been there, what is being looked at and put into words. This was what I recognised, understood, and wanted to be part of. Although I would certainly not have understood things in this way at the time, Hoggart's standpoint suggested I could salvage and put to good use what I had learned from living on both sides of the us/them divide. It promised that I might even bring them together, and heal the split.

From that moment, I was bent on a quest for knowledge that has

been a part of my life ever since. It is powered by a desire not just to understand my own past and come to terms with the divided and alienated consciousness that comes from it; but also to put together, in a sort of *bricolage* of a fragmented consciousness, a body of knowledge and a way of knowing that spring not from something imposed from outside but from what is rooted within. In pouring scorn on my 'book learning', my mother was setting what she regarded as my useless knowledge against hers, got the hard way, through living a tough life. Her claim was that if she knew nothing of the things I was learning at school, this did not mean she was ignorant. Implicit in this division of book learning and the lessons of life, I think, is an opposition between dominant (middle-class, male, white) ways of knowing on the one hand, and 'knowledge from below' on the other.

Knowledge from below, common knowledge, is often dismissed as superstition, 'female intuition', 'old wives' tales'; or at best patro-nised as 'folklore', the quaintly earthy wisdom of the unlettered. Looked at from a different standpoint, though, it can be seen as the knowledge of those who understand that the world does not belong to them, but who see themselves as belonging to the world: indige-nous peoples and peasants. To the extent that they inherit or share it, it is also the knowledge of the working classes of industrial societies, especially of the women among them. Common knowl-edge is mundane and practical: it makes use of the stuff of everyday life, and is always directed towards some useful purpose. Given that this knowledge would have been completely inadmiss-able to my school's social and academic agendas, my mother was right in her guess that I was being led away from things she knew and valued – and so from her. And indeed many years were to pass

before I saw the positive value of her ways of knowing, understood where it came from, and learned that this was a birthright that I had been enjoined to cast aside. My own quest for knowledge was, and is, driven more or less consciously by a desire to heal the breach between ways of knowing and bodies of knowledge that in our culture are split off from one another.

When I eventually went to university, the subject I chose, sociology, seemed to answer such a desire. If nothing more, I had at least turned aside from the security of the grammar school's track with its limited range of acceptable disciplines and its hurdles ordered at predictable intervals to join a more absorbing game with less familiar rules. I was fascinated by the idea of the sociological imagination, a way of knowing founded on a compassionate understanding of the invisible social forces that govern ordinary people's daily lives. I liked, and was oddly comforted by, the idea that my own life, with its difficulties and its successes, was not something one-off, nor about me alone, but part of a larger pattern that could be observed, described, analysed, theorised and, finally, understood. And even, perhaps, changed. I wanted to be part of these activities. If I was ultimately to become disillusioned with much of sociology, this was because the discipline too often downplays imagination and understanding, detaching itself from its own ways of knowing and treating its objects – very often in fact the working class – as in some way other, curiously one-dimensional specimens. There is too often a failure to imagine how social class is actually lived on the pulse, how it informs our inner worlds as it conditions our life chances in the outer world.

Being not a work of sociology but an early foray into cultural studies, *The Uses of Literacy* describes the working class and its

culture with an insight born of inside knowledge and empathy. In
doing this, though, it skirts dangerously close to nostalgia, the pit-
fall of the uprooted. Indeed the iconography and the structure of
feeling of *The Uses of Literacy* – the little terraced houses in their
rows of streets; the closeness and warmth of family and neigh-
bourhood ties; the spirit of endurance, cheerful or grumbling; the
enjoyment of a bit of fun to 'take you out of yourself'; the work-
worn but ever-affectionate 'mum' – all these things shape a
working-class romance that has become almost distressingly famil-
iar: from the plays and novels of the 'angry young men', to British
New Wave cinema, *Coronation Street*, and the films of Terence
Davies.

With its masculine viewpoint and its north of England setting,
this image of working-class life is very different from what I knew,
even if some of it is recognisable. The scholarship boy in *The Uses
of Literacy* is not me, even if I know all about his sense of belonging
nowhere. If this boy has had to renounce the vitality and toughness
of the streets, he does find comfort among the women of the house
as he settles to his homework on a corner of the kitchen table,
taking it as read that he has no part to play in their household
tasks. There is no place at this table, though, for the scholarship girl,
least of all for the London girl of the 'you've never had it so good'
era whose mother, after long hours of work in a cafe, seldom goes
near her own kitchen. Here, a grown daughter surrounded by
school books would be nothing short of provocation. The only
young women in Hoggart's account are the undifferentiated,
briefly-flowering girls in flimsy frocks and bright lipstick, the schol-
arship boy's flighty, factory-working sisters, giggling together on
their way to the cinema or the dance hall. The scholarship girl does

not belong with them, either. If she wants a role in this story, the scholarship girl must, it seems, create it for herself.

An earnest and gleeful fascination with forms of knowledge that would never have passed muster at my grammar school has fashioned the part of my education that I regard as my conscientisation, the awakening of a questioning attitude towards my own life and the world around me. Happily, once embarked upon, there is no end to critical consciousness, to the hunger to learn and to understand. Though perhaps for those of us who have learned silence through shame, the hardest thing of all is to find a voice: not the voice of the monstrous singular ego, but one that, summoning the resources of the place we come from, can speak with eloquence of, and for, that place.

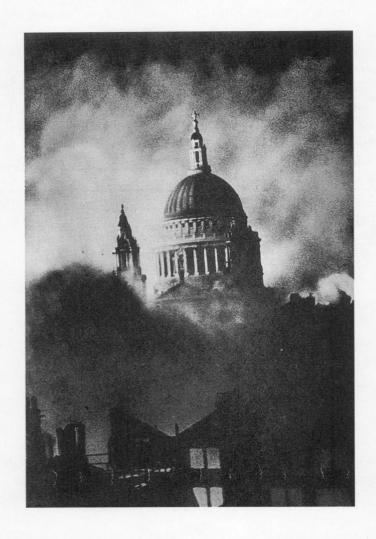

7

Phantasmagoria of Memory

Mourning is regularly the reaction to the loss of a loved person, or to the loss of some abstraction which has taken the place of one, such as fatherland, liberty, an ideal, and so on.

[Freud] portrays the process of mourning as a passionate or hyper-remembering of all the memories bound up with the person we have lost. Mourning is represented as a dizzying phantasmagoria of memory.

Phantasmagoria: *1. . . . an exhibition of optical illusions produced chiefly by means of the magic lantern . . . extended to similar optical exhibitions, ancient and modern. 2. a shifting series or succession of phantasms or imaginary figures, as seen in a dream or fevered condition, as called up by the imagination, or as created by literary description.*

This photograph is of St Paul's Cathedral during the Blitz on London in December 1940. It shows the Cathedral enveloped by the smoke from nearby fires started in a recent bombing raid, with ruins of burned-out buildings visible in the foreground, and the building emerging, apparently intact, from the chaos and

destruction all around. The contrast between the darkness of the smoke and the light bathing and framing the dome creates an image of quite elemental force; an image that spins off a series of associations that transport it into the domain of myth. In the context of a particular history, the mythic quality of this picture of an old, much-loved and familiar building at the heart of a capital city, standing unscathed amidst ruin wrought by enemy action, comes to stand for the indomitability, under attack, of an entire nation. It offers uplifting testimony of survival through adversity. If it speaks of resistance, this is a resistance of endurance, of 'taking it'. The enemy, not present in the image, becomes depersonalised and transformed into the natural, impersonal, energy of fire. The power of this image exceeds its historical moment because it embodies the archetypal and so lays claim to universal, timeless, meaning.

This photograph is among the most famous images of World War II, and a keystone in British popular memory of 'The People's War'. A print of it still hangs in St Paul's Cathedral. Much of the meaning and the feeling attaching to this highly overdetermined image rests upon hindsight, from which we look back upon a resolution that official history and popular memory agree to call a victory. Whatever might be my considered opinion on the construction of World War II as a moment of unprecedented national unity in my country, this image never fails to move me. If part of its message is universal, it nevertheless seems to speak to me – to interpellate me – in a very particular way.

In a similar way I am always moved – and not entirely against my better judgement – by *Listen to Britain*, a documentary film made two years after the Blitz by Humphrey Jennings and Stewart

McAllister. Produced by the Crown Film Unit under the auspices of the Ministry of Information as a piece of wartime propaganda, *Listen to Britain* blends a succession of discrete sounds and images into a portrait of a day in the life of a nation at war. Like the St Pauls photograph, this film has become an icon of the 'People's War'. And it does indeed draw upon a repertory of images and sounds which, seen and heard today, evoke meanings and affects very much akin to those attaching to the photograph.

Since I was born after the end of World War II, I have no lived memory of the events referenced in the film and the photograph; neither of which in any case I recall seeing until I was an adult with an interest in cinema and in cultural criticism. At some level, therefore, my response to both must be coloured by the distance conferred by a critical perspective and the passage of time. And yet there remains an odd sense in which I *recognise* these images: it is as if I had always known them. Of course, I can make no claim to know how people responded to them in 1940 or in 1942, when a resolution – that 'victory' which must inform our response today – was far from certain.

What interests me more is how it is that images and sounds of and from, or referring to, 'the past' – from a past indeed that precedes my own lifetime – can feel so familiar; and how this sense of recognition might connect with the activity of remembering, at both a personal and a collective level. What place do images and sounds occupy in the activity of remembering? Are they especially prominent among memory's pre-texts, source materials, forms of expression? What binds together images and sounds in personal memory with images and sounds in collective memory? What place do memory work and memory meanings hold in the stories we tell

each other about ourselves and our lives, about the places and the times we have lived in and live in now, about our destinies?

In *Camera Lucida*, Roland Barthes tells a story about finding, soon after her death, a photograph of his mother as a child. It seems he has never seen this photograph before; and yet it feels familiar. He senses that in this portrait of a little girl he perceives something about his mother that he does not see in other photographs, ones taken after his birth. This picture (which Barthes refuses to reproduce in his book on the grounds that its 'piercing' quality is for him alone and could not possibly touch the reader in the same way) becomes in effect the pre-text for writing, for putting into the text, that psychical struggle between holding on and letting go that characterises the activity of mourning. The photograph is all the more laden with meaning and affect for Barthes, all the more an occasion for that repeated, if terminable, remembering that is grief-work in that it brings to life a moment which he could not have witnessed.

Besides in its nature referring to events which cannot be retrieved or fully relived, then, remembering appears to demand no necessary witness, makes no insistence on the presence of the rememberer at the original scene of the recollected event. Remembering is clearly an activity that takes place for, as much as in, the present. Is memory then not understood better as a position or a point of view in the current moment than as an archive or a repository of bygones? Perhaps memory offers a constantly changing perspective on the places and times through which we – individually and collectively – have been journeying? Perhaps it is only when we look back that we make a certain kind of sense of what we see?

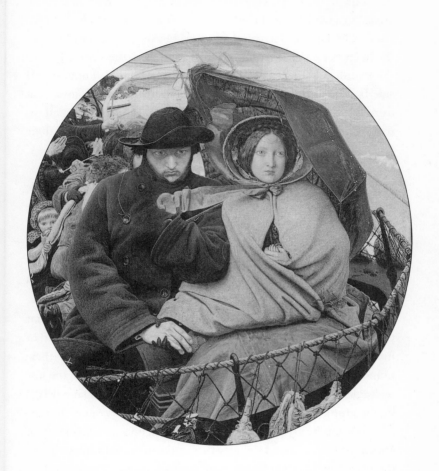

The title of Derek Jarman's 1987 film *The Last of England* is a reference to a work by the Pre-Raphaelite painter Ford Madox Brown. Painted in the mid nineteenth century (between 1852 and 1855) at the height of a period of mass emigration from the British Isles to the British colonies, 'The Last of England' shows a couple seated side by side at the stern of a small vessel bearing them away not from Britain but (as Albion's white cliffs at background right attest) from England. That the couple is middle class, and that their journey is evidently being undertaken in reduced circumstances, suggests that there is something tragic about their departure – whilst at the same time voicing the class standpoint of the artist, according to whom his emigrants are 'high enough, through education and refinement, to appreciate all they are now giving up, and yet depressed enough in means, to have to put up with the discomforts and humiliations of a vessel "all one class"'. The husband's doleful and the wife's wistful last look back at England certainly suggest that their departure is by force of circumstance. The painting's title refers not to what the spectator sees but to what the couple are looking – are looking *back* – at. In the reverse field of their gaze lies what they will remember as the last sight of their homeland, the familiar place they must now leave behind: the last of England. The promise for them is of a *memory* of England which lies in a future which, being in another place, is also out of frame.

Analogously, given the painting's reference to the exigencies of Victorian England and the artist's identification with his subjects, the decaying, doomed England of Derek Jarman's film is product at once of the filmmaker's vision (Jarman is in every sense in the picture, the sounds and images shown as being called up by his imagination) and of a perspective coloured by a particular

moment, particular circumstances. *The Last of England* – a less personal film, I believe, than it might seem – projects a vision, a nightmare about England, which has considerable purchase in the collective imagination.

For *The Last of England*'s collage of memory-images and memory-sounds includes many which to me feel strangely familiar, as if drawn from a commonly-held store of visual and auditory currency. A repertory of images of and from particular moments of the nation's past, with all the (sometimes contradictory or contested) meanings attaching to them in the present, emerges in this film as one (though by no means the only one) of its source materials. There are even several points at which such images evoke the iconographies of the St Paul's Cathedral photograph and of *Listen to Britain*. And the films – *The Last of England* and *Listen to Britain* draw on sound references, on music especially, which elicit feelings associated with a sense of national belonging.

For example in *Listen to Britain*, the soundtrack of the closing minute or so, a sequence of some sixteen shots incorporates a choral version of 'Rule Britannia':

Sequence showing a Royal Marines Marching band playing 'A Life on the Ocean Wave'. (Sound of the march blends into steel-mill rhythmic sounds.) In a steel mill, a worker draws molten ingot from a furnace. Closer shot of the ingot. CU molten mass being shaped. (On soundtrack, heavy pounding.) Workers bring out another ingot. CU ingot being placed on anvil. MS workers manipulating it. CU ingot. MS workers. CU ingot being shaped. Masked workers with welding equipment and sparks. (Mixed with the steel-mill sounds, a choir singing 'Rule Britannia' begins to fade in, then takes over

soundtrack.) Steelworkers on balcony above furnace. LS steelwork-
ers at furnace. Exterior, flat facade of factory surmounted by three
smoking shimneys. Waving field of wheat. Cooling towers and fac-
tory chimneys. Clouds drift across aerial view of countryside. ('Rule
Britannia' comes to a triumphant close.)

This sequence bears comparison with a passage in *The Last of
England* in which a very rapid montage of shots (some 150 in three
minutes) is orchestrated with Elgar's 'Pomp and Circumstance' on
the soundtrack in a manner which makes the image track itself
seem highly musical. The sequence is in two parts, corresponding
respectively with the 'Pomp and Circumstance' march itself and
then with 'Land of Hope and Glory'. In the first part, the multi-
tude of images in the montage separate into three distinct
categories: first a series of still photographs, in which the colours
red and yellow dominate, of monumental statuary which com-
bines icons of British imperialism (notably Queen Victoria) with
those of Indianness, of Hinduism in particular; second, some
black-and-white shots of masked gunmen, of a ruined or derelict
building, and of a building on fire and then exploding; finally,
extracts from colour home movie or amateur cinematography
footage of military parades, apparently in India in the 1940s –
showing various colonial armed forces in uniform, tanks, and air-
craft in an arid field encircled by mountains. In this section, all the
shots – some of them of less than a second's duration – are demar-
cated by cuts. In the second part, which begins soon after 'Pomp
and Circumstance' surges into 'Land of Hope and Glory' on the
soundtrack, the image track – on which individual shots now
involve more mobile framing and movement within frame – is

punctuated by dissolves and superimpositions. Along with the change of rhythm and tempo on sound and image tracks comes a shift in the content of the images themselves, which now divide into four sets: first, some rapid travelling shots, in black and white, past semi-detached houses in a middle-class English suburb; second, more imperialist statuary but now apparently in an English setting (these are photographed in silhouette, with some mobile framing and the colours blue and black dominating), a single shot of a crowd waving Union Jacks, and several colour shots of a wreath of Flanders poppies floating on water; third, a further series of black-and-white shots of the masked gunmen of the first section, and mobile shots of rubble and a wrecked building; finally, more of the colour home movie footage, which now includes some non-military subjects – tea being served by an Indian in full dress uniform to some Europeans in a garden, an oriental market or souk, as well as more squads of armed forces on parade in the same colonial setting as before.

These two sequences suggest some differences between *Listen to Britain* and *The Last of England* in their attitudes towards the issue of national identity. If *Listen to Britain*'s montage unites a discrete series of icons – the military, heavy industry, rural life and landscape – under the aegis of an anthem of national victory, producing an imagination of nationhood as harmonious in its internal differences, *The Last of England* offers a larger, less tidy, perspective. By juxtaposing images which reference England's past and its present, the 'Pomp and Circumstance' sequence asserts, while it condemns, the significance of the memory of an imperial history (the outward orderliness of the Empire cloaking the coercive quality of its militarism; its master ([European]–servant ['native'] ethos) in the

national imaginary of a contemporary England in which militarism now frankly figures as chaotic and destructive and patriotism (flagwaving) seems to be synonymous with pointless death *pro patria* (the Flanders poppies). In this England, the glory that was Empire lives on only in those genteel suburbs to which England's middle-ranking imperial servants retired when it was all over; and in the memories they brought back 'home' with them in their photographs and home movies.

And yet despite these differences, the two films do have a great deal in common; not only in their visual and auditory source materials, but also in the ways in which these materials are organised. There are the shared (or rather, given *The Last of England*'s broader brush, the overlapping) image and sound references, with their shorthand allusion to the mythopoesis of a particular national imaginary. There is the poetic, metaphorical, musical quality of the films' montages, whose sound/image associations defy literal description or linear narration. Both films, too, are very much products of the cutting room, assemblages of disparate pieces of visual material, some of it originally shot for other purposes (the 'Rule Britannia' sequence in *Listen to Britain* includes shots from at least two other films on which Humphrey Jennings had worked, and *The Last of England*'s 'Pomp and Circumstance' sequence contains, amongst other extrinsic material, amateur footage shot by Derek Jarman's father). In these respects, the two films share a constructionist aesthetic and a modernist sensibility. Their *bricolage* of visual and auditory fragments also confers a similar sense of timelessness on both films – which perhaps prompts the question: is there some inherent connection between poetry, memory and a sense of timelessness?

But if textual analysis reveals something about what *Listen to*

Britain and *The Last of England* have in common, I am not entirely satisfied that it exhausts the issue; nor indeed that its results answer the desire that brought me to this exercise in the first place. An attention to the films as texts does not address my feeling response to them; nor does it allow me to interrogate my intuition that something in that response unites the films at some deeper level. And so, since illustration is probably more apt than analysis in this sort of situation, here are two stories, one for each film.

The first story. As I tread the pavement outside the British Museum's main entrance in Great Russell Street, I am caught up in a reverie: a view from below of trees, light filtering down through the leaves. This transports me out of body, out of time; and is so intensely pleasurable an experience that I often deliberately call it up when I am in that particular place. The trees of my reverie are city trees, plane trees, probably, like the ones that in actuality line Great Russell Street. But they are not so mature as the real ones, the shade they cast is less dense. And while the British Museum is not actually there in my reverie, a building that I know for certain to be the Museum seems to be present, but out of frame. Although no such scene appears in the film, this experience is unequivocally associated for me with *Listen to Britain*; in particular with some bars from Mozart's Piano Concerto in G Major, the piece played by Myra Hess in the National Gallery sequence. This feeling is so strong that I am convinced my reverie must depend on my knowing the film. (If nothing more, this shows how our inner worlds can be shaped by a cinematic imagination – or perhaps that cinema mimics the workings of our inner worlds: in either case, it seems there is nothing literal or mimetic about any of these processes.)

The second story. It is July 1992 and I am walking home with a friend after dinner at a restaurant. It is twilight, the evening is warm (in my memory of the occasion, the sky is suffused with red, portent of more fine weather), and our stroll takes us to the passageway through the University of London's Senate House that connects Malet Street with Russell Square. As we emerge from Senate House, we are brought up short by the extraordinary sight of a huge rubbish skip filled to overflowing with books, and more books scattered around on the tarmac. One or two people have climbed up into the skip and are picking over the books. When I take one up, I see that it has been discarded by the University of London Library. I am profoundly disturbed: not so much by the surreally unsettling character of the scene, though that is certainly there, as by the power of its message to me about the value a society emerging from the Thatcherite 1980s places upon books, and thus on knowledge and learning. Although at the time I had seen the film only once, five years before, and had no detailed recollection of it, I knew straight away and beyond all doubt that if this was not an actual scene from *The Last of England*, it could very well be one.

Neither of these stories, I suspect, is in any way out of the ordinary, certainly in feeling tone if not in content. And I feel sure that it is not just among those with particular investments in cinema that films, or a cinematic way of seeing, figure so prominently in such imaginings. But it was one of these experiences – the second – that fuelled my intuition that there was something, something I could not yet name, that *The Last of England* shared with *Listen to Britain*. Possibly because this experience was so unsettling (impossible, unlike the other, simply to accept, delight in, relive; far more

demanding of explanation), my hunch was eventually to translate itself into the present exercise.

To get to the bottom of my intuition, I feel I must grasp what unites the two experiences by dealing with them on their own terms. When I do this, I am struck immediately by the intensity of a sense of *place* in both of them. The British Museum, while not actually in frame, figures as a prompt for the reverie – or rather, my actual presence in the vicinity of the Museum does. And not only is my memory of the Senate House scene remarkably precise as to location, place also figures centrally in the feelings associated with it. Apart from the not insignificant fact that Senate House and the British Museum house great libraries, both buildings figure centrally in my own mental map of London.

For a number of years, I have lived something more than intermittently in an area of London some distance from the part of the city I grew up in. I arrived there by a roundabout route that ensured that my adoption of this part of the city was a choice that freed me from my personal past. Over time, I have developed and refined a mental map of a part of London, including and spreading beyond my immediate neighbourhood, that I regard as 'my' territory. The boundaries of this map are drawn in my mind with the utmost precision; and the area within them known intimately. Each time I walk my territory (and walk it I must: no other means of getting about can be contemplated), I reacquaint myself with it, strengthen my sense of belonging. I never get lost; though because things change, I am sometimes surprised by what I find. I am reminded of something Michel de Certeau says about walking in the city: that it can be a reliving of the joyful and silent experience of childhood; and this seems to square with

the dreamlike, timeless state of delighted absorption induced by this activity.

Aside from their precision as to place, the scenes of both my stories involve geographical displacements. When I consider *Listen to Britain*, in particular the portion of the film in which the Piano Concerto (and more specifically, the brief passage from the piece that figures in my reverie) is performed, a particular series of shots from the film comes to mind:

> (Following the sequence in the National Gallery, the Piano Concerto continues over as the scene moves outside.) A woman on the Gallery forecourt reads in the sunshine. Plane tree leaves in the sun, viewed from below. View from Trafalgar Square to front elevation of Gallery, leaves and woman. CS woman on sunlit forecourt. From between Gallery pillars, low angle view of barrage balloon in sky above Trafalgar Square.

What I have done in my reverie is put myself into this scene; into the very position, in fact, from which the trees are framed. And yet something is different, there has been a displacement: the location has shifted to another part of the city, from the National Gallery to the British Museum. Not only have I inserted myself into the scene, I have also contrived to place it within the bounds of that piece of London which I regard as my own territory. And indeed whenever I watch *Listen to Britain*, there is always a brief moment in which I am convinced that the piano recital is taking place in the Museum.

There is a condensation, too: the National Gallery and the British Museum have become interchangeable, selections from a

paradigm of London's neoclassical buildings – a paradigm which, reaching towards another association, includes St Paul's Cathedral. Just as the plane trees of my reverie and of the film survive and thrive in the inauspicious setting of the city, so the Cathedral rises above the bombardment and the fires of the Blitz. And so – following the chain of associations further – do I; and so, returning full circle to *Listen to Britain*, does the nation. A reverie that carries me out of the here and now moves me into a time which offers not only the lure of the primal scene fantasy, but also that fascination with the recent past, and particularly with recent war, that marks everyday historical consciousness.

One detail in my memory of the Senate House incident is particularly insistent; and yet I have the strongest suspicion that it is an invention: the red sky. But why invent such a detail? Perhaps it ties the scene more firmly to *The Last of England*, my strongest recollection of which at the time was of omnipresent fire? Subsequent viewings of the film confirm the accuracy of that recollection: the film is indeed filled with images of burning: bonfires, torchlight flares, and – yes – red twilight skies over the Thames. In one characteristic passage, there is a rhythmic montage of dissolved and superimposed shots, brief and repeated: buildings on the north bank of the Thames, as seen from the river moving upstream from (again) St Paul's; a dwarf spinning a globe; flickering flames. As the sequence proceeds, the flames fill a larger area of the frame, and shots of masked gunmen enter the montage.

My probable invention of the red sky displaces the London docklands setting of *The Last of England* into my 'own' rectangle of the city, whilst setting off a further series of associations; beginning perhaps with the burning of books. This, given its reference

to a memory of war (or rather of Nazism, and thus specifically of World War II) and its association to the philistinism of Thatcherite and post-Thatcherite Britain, is completely in tune with the spirit of *The Last of England*, whose persistent flames continue to generate innumerable associations, from the historically specific to the personal, and finally to the elemental and the archetypal.

And I recall now that there is fire, too, in both *Listen to Britain* and the St Paul's photograph: little of it, and present mainly as possibility more than actuality (in the photograph we see smoke, not fire; in the film, firefighting equipment in the National Gallery sequence warns of an ever-present danger). In the climactic closing montage of *Listen to Britain*, however, fire actually bursts into the frame. The foundry sequence includes a medium shot (which would not be out of place in *The Last of England*) of workers welding, the sparks from their torches lighting up their masked faces; and, as 'Rule Britannia' rises to a crescendo on the soundtrack, a longshot of foundrymen stoking a furnace – this perhaps the film's consummate moment.

And for those who know it, fire is in the intertext of *Listen to Britain*, in the form of Jennings's next film, *Fires Were Started*, a fictionalised reconstruction of a night during the Blitz. *Fires Were Started* is set in the same Thames docklands (by the 1980s a different sort of wasteland) as *The Last of England*. And indeed one of *The Last of England*'s memory references is perhaps to the fires of London's Blitz and the survival of St Paul's. Fire is in the two films and in the photograph, finally, as an icon of a national imaginary. In *Listen to Britain* – and indeed in the photograph – it figures as a desire, a hope, that what we value of the past will survive the flames

and be renewed for the future in the ashes of destruction. In *The Last of England*, though, in disappointment and bitterness at the failure of this hope, the fires express the wish to cauterise the rottenness at England's core.

Along with their insistence on place, their highly overdetermined imagery, their allusions to and elaborations upon *Listen to Britain* and *The Last of England*, and their endlessly proliferating associations, what my two stories have in common above all is that in both I am placing myself firmly in the centre of the frame. Not only am I an observer at the scenes of my reveries; I also figure in them as a participant. More than that, I have contrived to redesign their mise-en-scene, and in the process even contributed some additional scenes. But what precisely are the desires that fuel such fantasies, such creations? Are they the same in each case, or are they different?

It is not difficult to grasp the desire behind the *Listen to Britain* reverie, which is very much a primal scene fantasy. Part of its intense pleasure must surely lie in its affirmation that I belong in this place where I am standing, that this place belongs to me and, above all, that my attachment to it reaches back to a time before I was born; most immediately to the years of a war that shaped the lives of my parents' generation, a war whose traces pervaded my early childhood. In my fantasy, I cast myself as witness of, and participant in, a moment when the most ordinary of activities (even, perhaps, walking along a treelined city street) becomes imbued with an aura of transcendence.

There is even a little family romance as well. When I watch *Listen to Britain* I know (and this is a sociological observation) that my mother might have, would have, been the girl at the factory

workbench, or any of the women in the factory canteen sequence. And yet the film somehow makes credible the idea that she could equally well have been one of the cultured, middle-class women who appear in the sequence that follows, the National Gallery piano recital. My reverie then combines a primal fantasy with a host of other fascinations (with the recent past, with recent war, with a family romance); and sets these into imaginings in which a sense of place, a sense of belonging to a place, are central. Hardly surprising, then, that it is so intensely pleasurable.

My second story, though, is less transparent. While the experiences recounted in both stories may speak to similar desires, desires that have to do in particular with a sense of belonging to a place, the reverie I associate with *The Last of England* is not obviously pleasurable, indeed seems somewhat complicated and contradictory. Is this perhaps a classically 'uncanny' experience, in which a sense of recognition of something familiar brings about a feeling of strangeness or unease rather than (or as well as) one of comfort? For although I am very much 'in' the scene of the Senate House incident, my role seems to be that of an engaged onlooker: like a child present a row between her parents, an onstage observer in a drama that is not my creation and in which I can claim no leading role. And yet I am caught up in it, passionately involved, and know that what I am witnessing will have profound resonances in my own life. The affect associated with my memory of this scene is sadness and despair. And indeed sadness and despair, tinged with the thrill of seeing one's most apocalyptic imaginings brought to life, pervade the feeling tone of *The Last of England*'s entire stunning array of sounds and images.

If the first experience – the one I associate with *Listen to*

Britain – offers the satisfaction of unity in diversity, gratifies the desire to belong, then, the second seems to speak for a more difficult, more alienated and questioning, belonging. Such a difference may be read across the formal organisation of *Listen to Britain* and *The Last of England*, and is even suggested in their respective titles: the unity and inclusiveness of Britain, a *United* Kingdom indeed; as against the mere fragment of that Union which is England.

Listen to Britain's montage fuses a series of discrete sounds and images into a synthesis of what even in 1942 was surely an imagined idyll of a rural past (summed up with succinctness in the lovely shot of the windblown wheatfield which appears at the beginning and at the end of the film) with icons of modernity, the age of industry and the machinery of war; melding images of the ordinary activities of people of all stations across, indeed beyond, the nation – truly a family portrait – into a set of timeless moments of communion between individual and collective, past and present. There is about *Listen to Britain* a perfection, an inevitability; as if these snatches of sound and image could have been put together in no other way. This feeling speaks exactly to a primal desire for union; and also to a national imaginary of (in Benedict Anderson's evocative word) *unisonality*.

Listen to Britain and *The Last of England* may indeed draw on a common stock of images and sounds, a shared repertory of visual and auditory myths of nationhood. They may even organise these sounds and images in a similarly poetic, allusive, metaphorical, manner. And yet while the overall tone of *Listen to Britain* is one of synthesis, that of *The Last of England* is of disintegration. *The Last of England* contains a considerably wider range of imagery and sound

reference than *Listen to Britain*, and much of it is disturbing, disgusting, abject. The icons of nationhood are there alongside other visual and auditory allusions which latter, if only by virtue of juxtaposition, then come to be associated with the idea of nationhood.

The 'Pomp and Circumstance' sequence, for instance, is preceded by a lengthy scene in which a man, naked but for boots, weaves and stumbles around a burning brazier set amidst rubble, tearing apart a cauliflower and eating it raw, kneeling as if in prayer, weeping, and then, as the opening bars of the 'Pomp and Circumstance' march mix into the complex sound montage that has accompanied this scene, vomiting. The pain and abjection of this scene meld into the feeling tone of the images and sounds that follow, images and sounds of past imperialism and a ruined contemporary England, overlaying impassioned iconoclasm with visceral disgust.

Images and sounds accrete, pile up on one another. The vision is kaleidoscopic; and in this hallucinatory dream, the familiar iconography of national myth seems to figure as if in quotation marks. Like the voice-over allusion to Harold Macmillan's 'wind of change' speech ('I grew up in the wind of change . . . blew away my reason'), the tone of the image quotations is often bitterly ironic. And yet this dazzling display has about it a compelling, desperate beauty. I am at once repelled and ravished: this is an irony that offers no safe distance. The sense of familiarity evoked by this film is a fusion of engagement and distance, seduction and abjection, plenitude and loss.

Does this mean that *Listen to Britain* and *The Last of England* work differently in terms of memory? Do they produce, if not different memories, differing relations to remembering? It seems to me that

Listen to Britain's work of memory, in offering wholeness, unity, harmony, enacts the disavowal characteristic of nostalgia. Knowing that the lost object (in this case a sense of shared purpose and an everyday world rendered auratic by an external threat to the nation) is irretrievable, one disavows that knowledge, and happily carries on remembering. *The Last of England*, on the other hand, with its truly 'dizzying phantasmagoria' of memory fragments spinning off in every direction, perhaps voices, in its frenzied lament, that painful and obsessive passion of remembrance, that struggle to come to terms with loss, which marks the work of mourning: that which is mourned in this case being, as Freud might put it, an abstraction that stands in for a lost loved one. The film's three closing shots are particularly telling:

1. B/W night. Six hooded figures stand in a boat, rowing. A seventh bears aloft a flaming torch. On this image is superimposed a 'screen' of what looks like glittering water. The boat moves slowly, but remains in frame. *Dissolve* to

2. Colour. Sunset over water, red sky. Sun glints on the water.

3. B/W as 1. Boat in closer shot, no superimposed 'screen', and now seen from behind. Again, the boat moves away, but remains fully in frame. Bird cry. *Fade* to black.

Is this perhaps an elegaic reference to 'The Last of England', the painting that inspired the film? But who, if so, is leaving; who remembering? As with the painting, the spectator is in the place of

what is left behind. But in the film the figures in the boat are obscure, and they do not look back. Should this be read as a gesture of parting, assurance of the letting go that promises the end of mourning? Or does the remembering never stop?

8

From Home to Nation

Writing this book has been a voyage of discovery, an Odyssey of the heart as much as of the mind. Like many who journey into unknown territory, I set out under the guidance of earlier travellers but soon found myself on my own, exploring new paths whose destinations lay far beyond my view. Although the journey continues and the story is not finished, I can now look back on the path taken so far and see that my journey through memory does, after all, have its own logic.

None of the essays in this book is a work of autobiography, but they all emerge from a critical interest in a genre of writing that might be called 'revisionist autobiography'. Since the mid-1980s, a number of books of a broadly autobiographical nature have appeared, written by intellectuals of my own generation. My first encounter with this body of work was *Truth, Dare or Promise*, a collection of essays by and about girls growing up in the 1950s. The stories in this book fascinate me not just because of their content (which resonates powerfully with memories of my own childhood),

147

but also because of the way the stories are told. In particular, most of the writers seem uncomfortable with the idea of an 'autobiographical self', certainly to the degree that this carries connotations of the transcendent ego of bourgeois and patriarchal individualism, of the power and *author*ity of the authorial voice. Given that all the contributors to *Truth, Dare or Promise* are feminists and that many of them describe themselves as socialists, this is perhaps not surprising. And yet how can these women write about themselves and their own lives without setting up those lives, those selves, as in some way unique, special, or exemplary? How, in other words, do they contrive to negotiate the formal conventions of autobiography, of writing about oneself?

Traditionally, autobiographies are written life stories organised as narratives whose beginnings, middles and ends are held together through the telling of an ordered sequence of events. The time of the narration has ready-made shape in the chronology of the writer's life: the story typically opens with his birth or early childhood, proceeds through various life stages, and ends at or near the time of writing. This sort of life story is characteristically presented, or read, as evoking a *Bildung*, an account of the development of the central character (the writer) over time. The present, the time of writing, is set up from the outset as the goal towards which the story will inexorably direct itself. Autobiography differs from fictional forms of storytelling in two main respects: events narrated make a claim to actuality (they 'really' happened); and the narrator, the writing I, is set up in a relation of identity with the central protagonist, the written I. Writer and subject purport to be one, the writer in the moment of writing being the same as, or a logical extension of, the self of the earlier years of the real life being written about.

This is itself a kind of fiction, of course. The linear narrative of conventional autobiography, its production of the narrator as a unitary ego, is the outcome of a considerable reworking of the rough raw materials of an identity and a life story. A kind of causal logic is taken for granted: the adult who is writing 'now' is contained within the child he writes about; events are ordered retrospectively from the standpoint of the present, the moment of telling, which is often also the moment of narrative closure. In consequence, the story is ordered and read as if this life could have been lived in no other way.

The source materials of the written life story are subjected to what psychoanalysis calls secondary revision. And in welding together the writing I and the written I – in producing narration, narrator and protagonist as indivisibly one – the conventional autobiography constructs a powerful central organising ego for its own story. But if autobiography is a specific writing strategy, one through which a certain self, a particular identity, is constructed and made public, both writing and identity can equally well be deconstructed: not only through criticism but also through other practices – most notably through stories of different lives, told differently.

A critical deconstruction would attend to the narrative strategies and rhetorical devices at work in autobiographical texts, and with the ways in which the autobiographical self is textually constructed. How, for example, might 'femininity' become an attribute of the self produced in women's (and men's?) autobiographical writing? How do writers construct themselves, or become textually produced, as belonging to a particular gender group or social class or generation or nationality or ethnic group? To what extent might

autobiographies 'write' their writers (and indeed their readers) across a range of different social, cultural and psychical categories, to produce complex and even contradictory subject positions, hybrid or fragmented identities?

The texts that fuelled my interest in autobiographical writing are revisionist in the sense that they incorporate into their writing implicit or explicit critiques, even deconstructions, of traditional modes of autobiographical writing. Their feminist and socialist authors come from a variety of class backgrounds, though almost all of them are white. The formation of many such British intellectuals of their generation ensures that most of these texts are informed in one way or another by psychoanalytic, mostly Freudian and post-Freudian, thinking. And the circumstances of their production combine to produce in these writings a scepticism about the reliability of memory and also an awareness of the pitfalls of an ego which sets itself up as transcendent.

Is 'theoretical self-consciousness and an explicit critique of the idea that individual stories can be "simply" evidential or authentic' compatible with the idea of any sort of autobiographical identity? And is there a connection between self-reflexive writing by contemporary socialist and feminist intellectuals and an older tradition of 'outsider' life stories, narratives produced by members of social groups whose stories have traditionally been untold, hidden, or silenced? How do life stories 'from below' – by women, by former slaves, by working-class men and women, for example – handle the relationship between life events, the narration of these events, and the narrating subject?

Significantly, for such 'outsider' autobiographers 'being a significant agent worthy of the regard of others, a human subject, as

well as an individuated "ego" for oneself' is not necessarily easy or to be taken for granted, and these writers also tend to shun the 'great I' of conventional or bourgeois autobiography. Does this attitude come with the territory of social, cultural or political marginality, whatever its form? Can a questioning of bourgeois or patriarchal notions of identity and a desire to redress social and historical injustices be reconciled in autobiographical writing? If so, how? Revisionist autobiography certainly attempts such a *rapprochement*: usually by insisting, within the writing itself, on a gap between the 'I' that writes and the 'I' (or perhaps better the 'me') that is written about; sometimes by drawing explicitly on formal bodies of knowledge or theories as frameworks within which to explore the 'I' or the 'me', and its place in history, its contingency.

Revisionist autobiography is not purely, nor arguably at all, about the lives and times of particular individuals: rather, it is about the relationship between the personal or the individual on the one hand and the social or the historical on the other – or, to put it another way, between experience and history. The self might be constructed, for example, as a product of patriarchal, psychical or social relations such as, say, class. In this sense, identity is regarded as not merely 'in process', but as a potential battleground as well. In these terms, the subject/object of the story cannot possibly be considered an exceptional, nor even a fully formed, individual. These writings also subvert assumptions about the transparency, authenticity, or 'truth' of memory, and to these ends materials not ordinarily considered pertinent to autobiography are sometimes brought into play in the writing. Among the most interesting examples of work in this vein are Ronald Fraser's *In Search of a Past* and Carolyn Steedman's *Landscape for a Good Woman*. Fraser

uses psychoanalysis as both theoretical model and narrational device, while Steedman draws on social history as a source of material to illuminate her own life and that of her mother. In both books, the narrating 'I' is in consequence fragmented, dispersed across different discourses.

In *Truth, Dare or Promise*, each essay includes a photograph of the writer as a child: this is usually a family snap or a school photo. As I recall, in none of the essays is the photograph commented upon: it appears to be present simply by way of illustration. What is the function of such images in the context of written accounts of these particular girlhoods? Are the photographs making some claim for the authenticity of the authors' childhood selves? Are they posing as evidence of some 'truth' about the past? If so, it is perhaps surprising that writings which are self-conscious about their own discursive strategies should not also take on board the discursive operations of photographic images. Even if the 'language' is different, images are just as much productions of meaning as words.

This raises a number of questions about how images like this – personal photographs of the kind that are preserved in family albums – are used by the people who make or own them. Personal photos have a particular, and very special, place in the production of memories about our own lives. In the twentieth century, countless millions were offered a new kind of access to the past through the democracy of family photography, and in our time family photos remain foremost among the mementoes we treasure. As part of a vast industry devoted largely to the cultivation of ideal images of the family, family photography constrains our remembering, tries to funnel our memories into particular channels. But it also has more subversive potential. It is possible to take a critical

and questioning look at family photographs, and this can generate hitherto unsuspected, sometimes painful, knowledge as well as new understandings about the past and the present, helping to raise critical consciousness not only about our individual lives and our own families, but about 'the family' in general and even, too, about the times and the places we inhabit.

To the extent that they are about the production of memory, personal photographs share something in common with autobiographical writing. At the same time, photographs lack the dimension of writing and thus perhaps the more revised public productions of self characteristic of conventional autobiography and even, in a different way, of revisionist autobiography. Personal photographs are commonly regarded as evidence that this or that event really happened, this or that person was actually present at a particular time and place: they seem, in other words, to stand as guarantors of the past actuality of some person or event. In everyday terms, the meanings of photographs are more often than not taken as self-evident.

As a cultural critic, I am concerned with how images make meanings. For me, every photograph contains a range of possible meanings, from those relating to the cultural conventions of image production to those which are to do with the social and cultural contexts in which the image was produced and is being used. These meanings seldom yield themselves fully to a surface reading: photographic images, far from being transparent renderings of a pre-existing reality, embody coded references to, and also help construct, realities. To unpick their meanings, photographs have to be deconstructed, too. Both personal photographs and autobiographical writing have a part in the production of memories, offering us

153

pasts which in one way or another reach into the present, into the moment of looking at a picture, or of writing or reading a text.

In her 'political, personal, and photographic autobiography' *Putting Myself in the Picture,* Jo Spence uses her personal photographs as source material, in much the way Ronald Fraser and Carolyn Steedman, in *In Search of a Past* and in *Landscape for a Good Woman*, draw on their own memories and dreams as material for interpretation. In a practice she calls 'visual autobiography', Spence uses her photographs as a set of texts to be 'read' – deconstructed and interpreted. Refuting the transparency commonly attributed to photographic images, Spence asserts their status as cultural artefacts, sometimes even suggesting that her photographs tell lies, or at least carry meanings which have as much to do with aesthetic and cultural conventions as with any unsullied 'truth' about 'Jo Spence', their subject.

It is but the shortest step from this to acknowledging that photographs may 'speak' silence, absence, and contradiction as much as, indeed more than, presence, truth or authenticity; and that while in the production of memory photographs might often repress this knowledge, they can also be used as a means of questioning identities and memories and of generating new ones. A 'visual autobiography' grounded in this premiss has this much at least in common with revisionist autobiographical writings. There is no 'peeling away of layers to reveal a "real" self', says Spence, but rather a constant reworking of memory and identity.

In these images and these texts, in these writings and these readings, a staging of memory is taking place. In *In Search of a Past*, Ronald Fraser's recourse to psychoanalytic inquiry allows him to show that the relationship between past events and our memories of

them is far from imitative, that we cannot access the past event in any unmediated form. The past is unavoidably rewritten, revised, through memory. And memory is partial: things get forgotten, mis-remembered, repressed. Memory, in any case, is always already secondary revision: even the memories we run and rerun inside our heads are residues of psychical processes, often unconscious ones; and their (re)telling – putting subjective memory-images into some communicable form – always involves ordering and organising them in one way or another.

My own journey through memory was very much inspired by these examples: revisionist autobiography's radical reworking of the written life story and visual anthropology's passionately questioning attitude towards personal photographs. I was led to look closely at the source materials of both practices – personal memories, photographic images and 'formal' bodies of knowledge – and their possible uses. Eventually, attention to materials, methods and uses was to subsume my original fascination with strategies of writing and reading. It was at this point that my explorations met an impasse: critical analysis, while opening up important and intrig-uing areas of investigation, was taking me no further along my path.

Partly because of an affective, almost a visceral, engagement with the material I was working on – I was experiencing a clear and forceful sense of what can only be called gut recognition – the dis-tanced standpoint of the critic began to feel less and less adequate to the material, incapable of addressing such powerful responses to it. I was captivated, intrigued, moved, by Fraser's, Steedman's and Spence's stories: they spoke to me in the most compelling way, engaging my own past, my own memories. Getting to grips with this response demanded that I should not stifle it by insisting upon

a critical distance, but that I ought perhaps to acknowledge it and bring it into play by embracing my own past and its representation through memory.

Letting myself take this path less travelled was to prove a turning point in this journey through memory. Admitting and addressing my own memory material was what made possible, indeed made necessary, the writing of this book. Moreover, my new path led me far beyond any personal history to which I might lay claim and into explorations of familial, cultural, national, and many other manifestations of collectively shared memory. Along the way, I made some discoveries about how memory works, observed in action some of the psychical and cultural processes through which memory organises both our inner worlds and the outer worlds of public expression and circulation of memory-stories, and gained insight into the connections between the two. I believe that this journey has produced a more profound lived understanding of the activity of remembering and of how remembering binds us as individuals into shared subjectivities and collectivities.

Memory has many uses, both individual and collective. At one extreme (to paraphrase Freud on hysteria) when there is too much of it and it is too compulsive, memory can be appallingly crippling. To extend the psychical outwards to the collective, we have only to call to mind the often bloody consequences of that hyper-remembering, that unremitting rehearsal of distant pasts, that marks the sectarian and tribal imaginations. If the certainties of sectarian memory inhabit one pole of a continuum – at whose midpoint perhaps lie inert forms of memory such as nostalgia and

heritage consciousness – at its other extreme are found forms of radical remembering that work actively and consciously to bring to light the repressed or the forgotten, whilst sustaining a critical and questioning attitude towards the past and towards memory and its uses.

This in effect is my understanding of memory work: an active practice of remembering which takes an inquiring attitude towards the past and the activity of its (re)construction through memory. Memory work undercuts assumptions about the transparency or the authenticity of what is remembered, treating it not as 'truth' but as evidence of a particular sort: material for interpretation, to be interrogated, mined for its meanings and its possibilities. Memory work is a conscious and purposeful performance of memory: it involves an active staging of memory; it takes an inquiring attitude towards the past and its (re)construction through memory; it calls into question the transparency of what is remembered; and it takes what is remembered as material for interpretation.

Memory work stages memory through words, spoken and written, in images of many kinds, and also in sounds: the multifaceted quality of memory-expressions is reflected in different practices of memory work. Word-memories, image-memories, even sound-memories are all important in the memory work performed in this book. From this work emerged some important lessons about memory: that the relationship between actual events and our memories of them is not mimetic; that memory never provides access to or represents the past 'as it was'; that the past is always mediated – rewritten, revised – through memory; and that the activity of remembering is far from neutral. Memory, it is clear, does not simply *involve* forgetting, misremembering,

repression – that would be to suggest there is some fixed 'truth' of past events: memory actually *is* these processes, it is always already secondary revision. But the radical remembering of memory work disdains any bleak agnosticism that such insights might otherwise produce.

In acknowledging the performative nature of remembering, memory work takes on board remembering's productivity and encourages the practitioner to use the pretexts of memory, the traces of the past that remain in the present, as raw material in the production of *new* stories about the past. These stories may heal the wounds of the past. They may also transform the ways individuals and communities live in and relate to the present and the future. For the practitioner of memory work, it is not merely a question of *what* we choose to keep in our 'memory boxes' – which particular traces of our pasts we lovingly or not so lovingly preserve – but of what we do with them, *how* we use these relics to make memories, and how we then make use of the stories they generate to give deeper meaning to, and if necessary to change, our lives today.

In conducting my memory work, I noted certain patterns and regularities in the ways memory is produced and constructed in memory texts; in formal and other textual characteristics of memory texts across media, matters of expression and genre; in the subjectivities memory texts produce for their users, both rememberers and 'recipients'; in the ways memory texts manage the tension between personal memory and the collective imagination, between the selfhood of the remembering subject and the the contexts in which memories are produced, textualised and used; in how the mise-en-scene of memories is characteristically imaged; in

how sound figures in memory texts; and in how narrative time is organised in memory-stories.

What follows is a summation, in six theses, of these observations. They are an attempt to give some form to what began as contingent and shapeless observations, and to explore the links and the discontinuities between personal and collective memory.

1. Memory shapes our inner worlds Memory inhabits, colours, and even forms, our inner worlds. In psychical terms, remembering (and, equally importantly, forgetting) is part of the properly human quest for origins which finds its most elemental expression in primal scene fantasies. You are present at your own conception or birth: you observe the scene; you are yourself, the child; you are one of your parents; you are both your parents; you occupy all these positions at once. Primal scene fantasies express a wish not just to be there at the scene of your own emergence into the world, but to author yourself, to be your own progenitor, and so to take command over the past, over a world in which you were not yet present. That you may assume any or all of the roles in the primal scenario answers a wish to be everywhere at once, to see, experience, know and remember all. Perhaps such fantasies of total power afford some compensation for (or disavowal of) the losses – beginning with separation from the mother's body – that are the human lot. Perhaps, too, a wish to return to a familiar and yet, once lost, *other*, place offers a pattern for the desires which surface in acts of memory.

In chapter 7, I note that memory does not necessarily depend on the rememberer's having been present at the remembered event, and that this sort of engagement with the past can be triggered by

particular places. An insistence on place in certain types of memory could certainly be an expression of a primal scene fantasy, a fantasy in which one is in a place, in a scene, and is at the same time in any number of other places within that scene. Perhaps memory shares the imagistic quality of unconscious productions like dreams and fantasies – for 'the Unconscious does not operate with the language of logic, but with images' – functioning in much the same way as the dreamwork, with its condensations, its displacements, gaps, non-causal logic and discontinous scenes.

The language of memory does seem to be above all a language of images. And if there is some connection between memory and the Unconscious, this might shed light upon the commonly unstraightforward relationship between memories and the 'real' past events to which they purportedly refer. Thus the often inexplicable feeling of familiarity attaching to many of the less tangible pre-texts of memory (places, sights, sounds, smells) might speak of a fantasy of union with the mother's body, a wish to return to that safe place. Because many of these psychical processes are in some degree unconscious, acts of remembering often bring forth thoughts and feelings that seem hard to explain in any rational way.

You are overtaken, say, by a sense that something has been irretrievably lost but have no idea what this lost object can be, or else you can name it only in the vaguest terms ('happier days', 'home'). Or you may yearn for the completeness, the security of days and places gone by whilst knowing that they cannot be retrieved and that they might never ever have been – and yet at the same time you disavow that knowledge. And so memory becomes tinged with the bittersweet, death-defying sadness of nostalgia. Perhaps being 'moved', as Barthes, writing in *Camera Lucida*, tells us he was on

finding the photograph of his mother as a girl, has something to do with a recognition of some thing, some moment, some feeling, that is close and familiar but which we can do nothing but accept is gone for ever.

2. Memory is an active production of meanings Once voiced, even in 'inner speech', memory is shaped by secondary revision. It is always already a text, a signifying system. This is the first stage at which memory produces meanings. For while it might refer to past events and experiences, memory is neither pure experience nor pure event. Memory is an account, always discursive, always textual. At the same time, memory can asssume expression through a wide variety of media and contexts. There is a world of difference between the memory-sharing of family members looking through the snaps for the hundredth time and the remembering provoked by the oral historian, for example, or between the written memoir and the autobiographical film. Some of these (books and exhibits of old photos of local scenes, say) offer themselves quite openly as occasions for personal or collective reminiscence, while published cultural commentaries (like Richard Hoggart's *The Uses of Literacy*) might include personal reminiscences among their source materials. Other types of memory text (a film like *The Last of England*, for example) may call up, in words, or with the directness and apparent purity of sounds or images, a sense of what remembering actually feels like. How much do these diverse memory texts have in common with each other?

3. Memory texts have their own formal conventions Memory texts of all kinds and in all media appear to

share certain formal attributes, though these are perhaps less apparent in texts like written and published memoirs that have undergone considerable revision at a conscious level and may move towards certain literary conventions. Particularly prominent among the peculiar characteristics of memory texts is a rather distinctive organisation of time: in memory texts, time tends not to be fully continuous or sequential. Literally, formally, or simply in terms of atmosphere created, the tenses of the memory text rarely fix events to specific moments of time or temporal sequences. Events are repetitive or cyclical ('at one time . . .'), or they seem set apart from fixed orders of time ('once upon a time . . .'). Relatedly, events narrated or portrayed in memory texts often (as in the 'convalescence' story told in chapter 2) telescope or merge into one another in the telling, so that a single recounted memory fuses together a series of possibly discrete events. Or events might follow one another in no apparent temporal sequence, or have no obvious logical connection with one another. The memory text is typically a montage of vignettes, anecdotes, fragments, 'snapshots', flashes.

All this produces a sense of synchrony, as if remembered events are somehow pulled out of a linear time frame or refuse to be anchored in 'real' historical time. Memory texts, being metaphorical rather than analogical, have more in common with poetry than with classical narrative. Events in the memory text often appear to have been plucked at random from a paradigm of memories and wrought uncomfortably into a 'telling' that is necessarily linear. (For the Formalist literary theorist Roman Jakobson, poetic language was precisely this twisting of paradigm onto linear syntagm; and in similar vein the experimental filmmaker Maya Deren spoke of

162

poetry in film as a vertical exploration – an investigation, through the particular temporality of this time-based medium, of a moment, image, or idea). The memory text stresses plot over story, in that the formal structure and organisation of the account are typically of as much, if not greater, salience than its content. Often, too, memory texts deliver abrupt and vertiginous shifts of scene and/or narrative viewpoint. The metaphoric quality, the foregrounding of formal devices, the tendency to rapid shifts of setting or point of view: all of these produce the characteristically collagist, fragmentary, timeless, even musical, quality of the memory text.

Derek Jarman's film *The Last of England*, which is discussed in chapter 7, embodies all of these qualities, as in rather different ways does Terence Davies's *Distant Voices, Still Lives* (1988). Significantly, both films prioritise images and sounds over the spoken (or written) word, and neither offers a linear narrative. Although *Distant Voices, Still Lives* is evidently 'about' a working-class childhood in Liverpool (a sense of place is a key feature, though much more important than the city is the intimate space of the family house, laid out and explored on the screen in lovingly intense detail), it is impossible, without being perversely auteurist, to label the film autobiographical in any conventional sense. Of any narrating autobiographical 'I' there is no trace: there is no enunciative voice capable of attribution to any particular individual narrator or character. And the pastness of the film's obviously highly invested mise-en-scene declines to attach itself to specific dates. While the events shown appear to span a period of time between the early war years and the mid to late 1950s, they are not narrated in any linear order of time, nor is there any classical flashback structure.

Revealingly, the mother in *Distant Voices, Still Lives* – the epitome

of the martyred, enduring working-class mum – looks exactly the same throughout the film. Events are often presented in apparent isolation from, as if temporally or causally unrelated to, one another. Other kinds of association are at work: episodes are narrated in the manner of a series of anecdotes or family stories honed by years of repetition, or else appear on the screen as visual/audial memory-flashes – music and songs are especially prominent. Elsewhere, recurrent scenes – of pub singsongs and family gettogethers and rituals in particular – produce a sense of time as cyclical: as with the family album discussed in chapter 2, this is a version of 'timelessness' in which life's peak events, the rituals of birth, marriage and death, inexorably repeat themselves, and never really change.

Although, or perhaps because, *Distant Voices, Still Lives* affords no obvious single point of identification, it induces a certain sense of recognition. This is not because the remembered places and events of the viewer's childhood necessarily resemble those in the film: if there is authenticity here, it is not that of naturalism, nor even of realism. It is more that the film contrives to convey the affect, the structure of feeling, that attaches to all childhood memory. Though this might not be quite universal: one of the formal qualities of the memory text – its organisation of time as cyclical rather than as sequential – arguably captures something of what it feels like to live, or rather to remember living, in a particular kind of family and a certain class setting. In either case, this example serves, if nothing else, to show that even the most apparently 'personal' and concrete contents and forms of remembering may have a purchase in the intersubjective domain of shared meanings, shared feelings, shared memories.

4. Memory texts voice a collective imagination What links personal memory with its shared, collective, counterparts, and how do the formal properties of memory texts figure in this encounter? Assuming that all memory is in any case secondary revision, and that all memory texts are shaped by conventions that are by definition collectively held, perhaps the distinction between personal and collective memory can be regarded as a false dichotomy? Or would this be too reductive? Do these observations not simply confirm that the psychical and the social are always intertwined?

If memory texts have little truck with the conventions of classic realist narrative, they do tell stories of another sort. One type of memory text, for example – raw oral history interview material – often combines historical, poetic and legendary forms of speech, whilst still expressing both personal truths and a collective imagination. As Alessandro Portelli has observed of oral history life stories, 'The degree of presence of "formalised materials' like proverbs, songs, formulaic language, stereotypes, can be a measure of the degree of presence of "collective viewpoint"'. Such memory texts create, rework, repeat and recontextualise the stories people tell each other about the kinds of lives they lead. In the process, the stories often take on a timeless, mythic quality which grows with each retelling. This mythmaking process works at the levels of both personal and collective memory and is key in the production, through memory, of collective identities. Popular memory of the Coronation, discussed in chapter 4, is a case in point.

Sayings like 'You'll eat a peck of dirt before you die' and 'Hard work never did anybody any harm' punctuated my mother's tales of her own childhood, and call to mind those formulaic, even cliched,

utterances oral historians observe in their informants' stories. Telling and retelling their memories is one of the strategies people use not only to make sense of the world, but to create their own world and to give themselves and others like them a place, a place of some dignity and worth, within it. In her sayings, my mother casts herself not merely as the victim of a poverty-stricken youth, but as heir to a proud tradition of endurance: 'we' are the people who are ennobled as well as toughened by hard work. The community affirmed by these formulae is one of class and generation. Through these sayings, my mother merges her own identity into a collective one, in much the same way the working-class authors of the life stories discussed by Regenia Gagnier avoid the transcendent 'I' in their narratives, so instating a continuity of individuality and community. Other working-class life stories, especially those produced by individuals like Terence Davies and Richard Hoggart who have left their class of origin behind, are often narrated – necessarily from the standpoint of the 'present' – in terms of the marginality, the not-belonging, the struggle for identity, of an 'uprooted' narrator.

Thus in making sense of, we also imagine, and make, a shared world. Memory texts translate the psychical activity of warding off loss into the domain of the social. A compulsion to tell and retell the same stories, to the point indeed that they become formulaic, has about it the air of a wish to forestall, even evade, death. People seek to hand on the contents of their memory-bank to future generations, and so to ensure collective immortality.

5. Memory embodies both union and fragmentation Memory texts are made, shared and re-made in many

different contexts: but it is perhaps the family that provides the model for every other memory-community. Every family has its stories – its cast of characters, its anecdotes about what so-and-so did when, its 'we used to's (not to mention its amnesias and secrets). While stories like this are obviously not confined to families, the shared remembering and complicit forgetting that goes on inside families provide the model for other communities – of ethnicity, class, generation, and so on – and for the idea of nation as family, with its assumption of, or desire for, a past held in common by all its members, a past that binds them together today and will continue to do so into the future.

The condition of modernity brings with it changes in how we relate to and how we produce memory. A modern individual regards what she or he remembers as the source of their own singular identity. At the same time, the era of mechanical reproduction and electronic simulation offers new outlets for the circulation of collective memory: sound recordings, photographs, television programmes, films, home videos are all part of the currency of daily life. At the same time modernity offers new ways of imagining a past that, as almost everyone alive today cannot fail to see and hear, transcends the life of the individual. Memory texts proliferate – there are more of them, across more media – as memory-communities overlap, merge, fragment. In modernity, collective remembering can divide, fragment, hybridise, unite, enrich.

How can this be? In the psyche, the drive that powers acts of remembering would seem to exert a specific kind of pull: the desire, often only partly conscious, for a lost 'home' grounds the work of memory as quest for union, re-union, wholeness. The timeless quality of memory texts; their extreme investment in place, in the *scene*

of memory; their repetitive, formulaic, quality; their characteristic emotional tone – all these things add up to an impetus towards fusion, not fragmentation. In the collective domain, this translates as a search for common imaginings of a shared past. While memory's desire runs in harness with the condition of modernity, public memory may be comprised of a melange of smaller collective memory-stories, always in flux and always potentially in contradiction with one another. Remembering can be the occasion for cultural difference, even for conflict, as well as for solidarity.

Everyday historical consciousness and collective memory overlap, however, in stories about the recent past, that past which falls within the timespan of our parents' and our grandparents' memories. Here, remembering of the kind that goes on inside families feeds into the consciousness of a history that transcends the memory of any individual or family:

> the period of the past experienced by means of family stories . . . differs qualitatively from times previous to it. Here, historical imagination is entangled with one's particular social origin and this differs from the way one imagines other, even earlier epochs and their struggles.

6. Memory is formative of communities of nation-hood Memory's imaginings accrete in formulae, cliches, stereotypes, and these come to function as a shorthand for clusters of shared memory-meanings. With its foothold in both the psyche and in the shared worlds of everyday historical consciousness and collective imagination, memory has a crucial part to play in any national imaginary. Significantly, the word 'nation', with its roots in

the Latin *nasci* (to be born), is defined in terms of both common culture and history and also shared space or territory. When associated with ideas of nationhood, memory feeds into a conception of a history that is 'ours', and that belongs to all of 'us'. The historical imagination of nationhood has something about it of the acts of remembering shared by families and other communities, and also of the desire for union, for wholeness, that powers the psychical dimensions of remembering. It is in the idea of the homeland, and above all in that of the 'motherland', that all of these aspects of the national imaginary are condensed, and home and nation come together.

Notes

1 Family Secrets: an Introduction

page 1 *'. . . feelings we have in the present'* Thomas Moore, *Care of the Soul: a Guide for Cultivating Depth and Scaredness in Everyday Life* (New York: HarperCollins, 1994), p. 220.

page 1 *our 'imagined communities'* See Benedict Anderson, *Imagined Communities: Reflections on the Origin and Spread of Nationalism* (London: Verso, 1983).

page 7 *for their phototherapy and family album work* Rosy Martin and Jo Spence, *Double Exposure: the Minefield of Memory* (London: Photographers Gallery, 1987). See also Jo Spence, *Putting Myself in the Picture: a Political, Personal and Photographic Autobiography* (London: Camden Press, 1986); Rosy Martin and Jo Spence, 'Phototherapy: psychic realism as a healing art?' *Ten-8*, no. 30 (1988), pp. 2–17; Jo Spence and Patricia Holland (eds), *Family Snaps: the Meanings of Domestic Photography* (London: Virago, 1991).

page 9 *'. . . dramatic, everyday and historic'* John Berger, 'Uses of photography', in *About Looking* (New York: Pantheon Books, 1980), p. 63.

page 9 *and the lives of those around them* Paulo Freire, *Pedagogy of the Oppressed* (Harmondsworth: Penguin, 1972).

page 9 '. . . *lives for which the central interpretive devices of the culture don't quite work*' Carolyn Steedman, *Landscape for a Good Woman: a Story of Two Lives* (London: Virago Press, 1986), p. 5.

2 'She'll Always Be Your Little Girl . . .'

page 18 *the **studium**, the evidential, however intricately coded* Roland Barthes, *Camera Lucida* (London: Flamingo, 1984).

3 The Little Girl Wants to be Heard

page 25 *the pivotal figure of a family drama* *Mandy*, d. Alexander Mackendrick; p. Leslie Norman; sc. Jack Whittingham and Nigel Balchin; cast Jack Hawkins (Richard Searle), Terence Morgan (Harry Garland), Phyllis Calvert (Christine Garland), Mandy Miller (Mandy Garland); released July 1952. US title: *Crash of Silence*.

page 30 *naturalistic realism more familiarly associated with Ealing films* For a critical and historical overview of Ealing see, for example, Charles Barr, *Ealing Studios* (London: Cameron and Tayleur, 1971).

page 31 *that were to issue from Hollywood later in the 1950s* On melodrama and cinema see, for example, Christine Gledhill (ed.), *Home Is Where the Heart Is: Studies in Melodrama and the Woman's Film* (London: BFI Publishing, 1987).

page 43 *the surreal character of the scene* The manikins in a bombed-out shopfront in *London Can Take It* (Humphrey Jennings/Harry Watt, GPO Film Unit for Ministry of Information, 1940), for example. In her novel *Memory Board* (London: Pandora Press, 1987), Canadian author Jane Rule describes Blitz-torn London as a place where 'a teapot could easily be found in the middle of the road as on a kitchen counter'. The script of *Mandy* places the grandparents' house in 'an area showing a contrast of social classes . . . originally an exclusively upper-class district. In the post-war years, however, it has quickly deteriorated. The bomb damage has not been rebuilt

and the houses are badly in need of exterior redecoration The Garland house fights a lonely battle against the general deterioration all round.' *Mandy*, Final Shooting Script, British Film Institute Library.

page 44 *a guarded optimism about the future*? For another interpretation, see Pam Cook, 'Mandy: daughter of transition', in Charles Barr (ed.), *All Our Yesterdays: Ninety Years of British Cinema* (London: BFI Publishing, 1986), pp. 355–61. Philip Kemp also discusses the film, in his *Lethal Innocence: the Cinema of Alexander Mackendrick* (London: Methuen, 1991), pp. 68–87.

4 A Credit to Her Mother

page 57 *of having and keeping me* On mothering and the economic understanding of childhood, especially within the working class, see 'Reproduction and refusal', in Carolyn Steedman, *Landscape for a Good Woman: A Story of Two Lives* (London: Virago,1986), pp. 83–97.

page 60 *making a cissy of him* In responding to a draft of this essay, and speaking from experience as a professional photographer, Jo Spence comments (in a letter to the author, July 1991) that the mothers of boys she photographed did in fact dress them up for the occasion, but 'to look smart – i e to displace the scruffiness of daily life . . . [M]others continually smooth boys' hair close to the head if it flops. They need to be a credit in a different way, ie will they grow up to have respect, be powerful?' Spence also notes historical or generational differences in mothers' displays of girl children (and also in girls' self-displays).

page 61 *gender difference naturalised in certain clothing styles* For a discussion of clothes as performance, see Annette Kuhn, 'Sexual disguise and cinema', in *The Power of the Image: Essays on Representation and Sexuality* (London: Routledge and Kegan Paul, 1985), pp. 48-73. Judith Butler discusses 'gender performatives' in her *Gender Trouble:*

Feminism and the Subversion of Identity (New York: Routledge, 1990), chapter 3(iv).

5 A Meeting of Two Queens

page 73 *Sunday best, uniform* On types of family photograph, see Julia Hirsch, *Family Photographs: Content, Meaning and Effect* (New York: Oxford University Press, 1981).

page 81 *events on a grander, more public, scale* For a discussion of popular memory, see Popular Memory Group, 'Popular memory: theory, politics, method', in Centre for Contemporary Cultural Studies, *Making Histories: Studies in History-writing and Politics* (London: Hutchinson, 1982), pp. 205–52.

page 85 *of the Coronation ceremony* Philip Ziegler, 'Coronation, 1953', in *Crown and People* (New York: Alfred A Knopf, 1978), pp.97–126. See also Brian Barker, *When the Queen Was Crowned* (London: Routledge and Kegan Paul, 1976). For a social history of Britain in the immediate postwar years see, for example, Paul Addison, *Now the War Is Over: A Social History of Britain*, 1945–51 (London: Jonathan Cape, 1985).

page 85 *plentiful food prepared and consumed collectively* The ox-roasts which apparently featured in many Coronation festivities (see Ziegler, 'Coronation, 1953') combine the timeless quality of ritual with (at a time when meat was still rationed) the most pressing preoccupations of the moment.

page 86 *qualities of folk religious observance* Edward Shils and Michael Young, 'The meaning of the Coronation', *Sociological Review*, vol. 1, no. 2 (1953), pp. 63–81. Shils and Young's contribution is indebted to Durkheim's discussion of religious observance in 'primitive' societies in the conclusion of *The Elementary Forms of the Religious Life*, trans. Joseph Ward Swain (London: Allen and Unwin, 1915), pp. 415–47.

page 86 *joyfully and devoutly incorporated into the low* On the carnivalesque, see M. M. Bakhtin, *Rabelais and His World*, trans. H. Iswolsky

(Cambridge, MA: MIT Press, 1968); Peter Stallybrass and Allon White, *The Politics and Poetics of Transgression* (Ithaca, NY: Cornell University Press, 1986).

page 86 *'to make it a bit gay'* Ziegler, 'Coronation, 1953', pp. 102–3.

page 87 *'. . . against my principles to feel like that'* Ziegler, 'Coronation, 1953', pp. 102–3.

page 87 *'. . . harassing exigencies of mundane existence'* Ernest Jones, 'The psychology of constitutional monarchy', in *Essays in Applied Psycho-Analysis* (London: Hogarth Press, 1951), pp. 227–33 (p. 232).

page 88 *civic ritual as a mass mediated spectacle* See David Chaney, 'A symbolic mirror of ourselves: civic ritual in mass society', *Media, Culture and Society*, vol. 5, no. 2 (1983), pp. 119–35.

page 89 *'. . . completely ignoring the heavy rain which was falling'* *Illustrated London News*, 13 June 1953.

page 90 *Salote, Queen of Tonga* Ziegler, 'Coronation, 1953', p. 122.

page 93 *'. . . the Royal Family album'* Barker, *When the Queen was Crowned*, p. 210.

page 96 *that default ethnic identity: white* On early representations – especially photographs – of migrants to Britain from the West Indies and elsewhere, see Stuart Hall, 'Reconstruction work: images of post-war black settlement', in Jo Spence and Patricia Holland (eds), *Family Snaps: The Meanings of Domestic Photography* (London: Virago, 1991), pp. 152–64. For an enlightening discussion, from the standpoint of the formerly colonised, of the psychological and structural impact of colonialism on the colonising nation, see Ashis Nandy, *The Intimate Enemy: Loss and Recovery of Self Under Colonialism* (Delhi: Oxford University Press, 1983), pp. 29–48.

6 Passing

page 104 *masses beyond the school walls* For a discussion of the ethos of the girls' grammar school, see Mary Evans, *A Good School: Life at a Girls' Grammar School in the 1950s* (London: Women's Press, 1991).

page 108 '. . . *serious-minded organisers of voluntary associations*' Evans, *A Good School*, p. 81.

page 109 *decidedly did not fit* In their study of working-class children at grammar schools in the north of England, Brian Jackson and Dennis Marsden quote one female ex-pupil's comments on her uniform: '[it] was too big all round . . . I suppose my mother had to do it like that so it would last longer, but I felt awful. All the other girls' uniforms seemed all right. *I* was wrong'. *Education and the Working Class* (London: Routledge and Kegan Paul, 1962), p. 95.

page 113 *perhaps four or five went on to grammar schools* In the 1950s and 1960s, countless sociological studies exposed the class bias of the 11-plus examination. See, for example, Jean Floud and A. H. Halsey, 'Social class, intelligence tests, and selection for secondary schools', in A. H. Halsey et al, *Education, Economy and Society: A Reader in the Sociology of Education* (Glencoe, IL: Free Press, 1961), pp. 209–15; Jackson and Marsden, *Education and the Working Class*; D. F. Swift, 'Social class analysis', in B. R. Cosin et al (eds), *School and Society: A Sociological Reader* (London: Routledge and Kegan Paul and Open University Press, 1971), pp. 251–4.

page 116 '. . . *generations gone before*' Jackson and Marsden, *Education and the Working Class*, p. 172.

page 117 *return to haunt you for the rest of your life* On being an educated woman from a working-class background, see Rosy Martin, 'Phototherapy: the school photo (happy days are here again)', in Patricia Holland et al (eds), *Photography/Politics: Two* (London: Comedia, 1986), pp. 40–2; Pam Trevithick, 'Unconsciousness raising with working-class women', in Sue Krzowski (ed.), *In Our Experience: Workshops at the Women's Therapy Centre* (London: Women's Press, 1988), pp. 63–83; Valerie Walkerdine, 'Dreams from an ordinary childhood', in *Schoolgirl Fictions* (London: Verso, 1990), pp. 161–70; Rosy Martin, 'Unwind the ties that bind', in Jo Spence and Patricia Holland (eds), *Family Snaps: The Meanings of Domestic*

Photography (London: Virago, 1991), pp. 209-21.

page 118 **The Uses of Literacy** Richard Hoggart, *The Uses of Literacy* (London: Chatto and Windus, 1957); Stuart Hall and Paddy Whannel, *The Popular Arts* (London, Hutchinson, 1964); Denys Thompson (ed.), *Discrimination and Popular Culture* (Harmondsworth: Penguin, 1964).

page 120 *especially of the women among them* For a discussion of the 'conjectural model' which grounds the epistemology of knowledge from below, see Carlo Ginzburg, 'Morelli, Freud and Sherlock Holmes: clues and the scientific method', *History Workshop Journal*, no. 9 (1980), pp. 5–36

page 121 *our life chances in the outer world* Exceptions to this generalisation include Jackson and Marsden's *Education and the Working Class*, as well as other publications of the Institute of Community Studies; and Richard Sennett and Jonathan Cobb, *The Hidden Injuries of Class* (New York: Alfred A. Knopf, 1973).

page 123 *my own life and the world around me* See Paulo Freire, *Pedagogy of the Oppressed* (Harmondsworth: Penguin, 1972).

7 Phantasmagoria of Memory

page 124 '. . . *fatherland, liberty, an ideal, and so on*' Sigmund Freud, 'Mourning and melancholia' (1917), *Collected Papers, volume 4*, trans. Joan Riviere (New York: Basic Books, 1959), p. 153.

page 124 '. . . *phantasmagoria of memory*' Kathleen Woodward, 'Freud and Barthes: theorizing, mourning, sustaining grief', *Discourse*, vol. 13, no. 1 (1990–1), p. 95.

page 124 '. . . *created by literary description*' Oxford English Dictionary.

page 130 '. . . *a vessel "all one class"*' Ford M. Hueffer, *Ford Madox Brown: a Record of His Life and Works* (London: Longmans, Green and Co., 1896), p. 100.

page 132 *comes to a triumphant close* This description is adapted from the shot breakdown of *Listen to Britain* in Anthony W. Hodgkinson and

Rodney E. Sheratsky, *Humphrey Jennings: More than a Maker of Films* (Hanover, NH: University Press of New England, 1982), pp. 135–40.

page 137 *joyful and silent experience of childhood* Michel de Certeau, 'Walking in the city', in *The Practice of Everyday Life*, trans. Steven Randall (Berkeley: University of California Press, 1984), p. 110.

page 139 *everyday historical consciousness* Patrick Wright, 'Introduction: everyday life, nostalgia and the national past', in *On Living in an Old Country: the National Past in Contemporary Britain* (London: Verso, 1985).

page 143 *individual and collective, past and present* Malcolm Smith, 'Narrative and ideology in *Listen to Britain*, in Jeremy Hawthorn (ed.), *Narrative: from Malory to Motion Pictures* (London: Edward Arnold, 1985).

page 143 **unisonality** Benedict Anderson, *Imagined Communities: Reflections on the Origins and Spread of Nationalism* (London: Verso, 1983), p. 132.

8 From Home to Nation

page 147 *girls growing up in the 1950s* Liz Heron (ed.), *Truth, Dare or Promise: Girls Growing Up in the Fifties* (London: Virago Press, 1985).

page 149 *secondary revision* 'rearrangement of a dream so as to present it in the form of a relatively consistent and comprehensible scenario': J. LaPlanche and J-B. Pontalis, *The Language of Psycho-Analysis* (London: Hogarth Press, 1973), p. 412.

page 149 *a powerful central organising ego for its own story* For criticisms of such writing from a feminist standpoint, see Frigga Haug et al., *Female Sexualisation* (London: Verso, 1987).

page 150 '*. . . individual stories can be "simply" evidential or authentic'* Laura Marcus, ' "Enough about you, let's talk about me": recent autobiographical writing', *New Formations*, no. 1 (1987), pp. 77–94. The quotation is on p. 78.

page 151 '*. . . as well as an individuated "ego" for onself'* Regenia Gagnier,

Subjectivities: A History of Self-Representation in Britain, 1832–1920 (New York: Oxford University Press, 1991), p. 141.

page 151 **Landscape for a Good Woman** *In Search of a Past* (London: Verso, 1984); *Landscape for a Good Woman: a Story of Two Lives* (London: Virago Press, 1986).

page 152 *the people who make or own them* Patricia Holland, 'Introduction: History, memory and the family album', in Jo Spence and Patricia Holland (eds), *Family Snaps: the Meanings of Domestic Photography*. (London: Virago Press, 1991).

page 154 *memories and dreams as material for interpretation* Jo Spence, *Putting Myself in the Picture: a Political, Personal and Photographic Autiobiography* (London: Camden Press, 1986). See also Spence, *Cultural Sniping: the Art of Transgression* (London: Routledge, 1996).

page 154 *'peeling away of layers to reveal a "real" self'* Spence, *Putting Myself in the Picture*, p. 97.

page 160 *'the Unconscious does not operate with the language of logic, but with images'* Rosy Martin and Jo Spence, 'Photo-therapy: psychic realism as a healing art?', *Ten-8*, no. 30 (1988), p. 16.

page 163 *an investigation . . . of a moment, image, or idea* Roman Jakobson, 'Linguistics and poetics', in Richard and Fernande De George (eds), *The Structuralists: from Marx to Levi-Strauss* (New York: Anchor Books, 1972); Maya Deren, in her contribution to 'Poetry and the film: a symposium', *Film Culture*, no. 29 (1963), pp. 55–63.

page 164 *a particular kind of family and a certain class setting* See Carolyn Steedman's discussion of the film in 'Class of heroes', *New Statesman and Society*, 14 April 1989, p. 27.

page 165 *'. . . a measure of the degree of presence of a "collective viewpoint"'* Alessandro Portelli, 'The peculiarities of oral history', *History Workshop Journal*, no. 12 (1981), p. 99. See also Luisa Passerini, 'Memory', *History Workshop Journal*, no. 15 (1983), pp. 195–6.

page 166 *discussed by Regenia Gagnier* See Gagnier, *Subjectivities*.

page 168 *'. . . even earlier epochs and their struggles'* Burkhardt Lindner,

'The *Passagenwerk*, the *Berliner Kindheit*, and the archaeology of the "recent past"', *New German Critique*, no. 39 (1986), p. 43. See also Patrick Wright, ' Introduction: everyday life, nostalgia and the national past', in *On Living in an Old Country: the National Past in Contemporary Britain* (London: Verso, 1985).

page 169 *common culture and history and also shared space or territory* The *Shorter Oxford Dictionary*'s principal definition of 'nation' is: 'A large aggregate of people so closely associated with each other by factors such as common descent, language, culture, history and occupation of the same territory, as to be identified as a distinct people'. See also Benedict Anderson, *Imagined Communities: Reflections on the Origins and Spread of Nationalism* (London: Verso, 1983).

Further Reading

Anderson, Benedict, *Imagined Communities: Reflections on the Origins and Spread of Nationalism*. London: Verso, 1983.

Barthes, Roland, *Camera Lucida*. London: Fontana, 1984.

Berger, John, *About Looking*. New York: Pantheon Books, 1980.

Evans, Mary, *A Good School: Life at a Girls' Grammar School in the 1950s*. London: The Women's Press, 1991.

Fraser, Ronald, *In Search of a Past*. London: Verso, 1984.

Gagnier, Regenia, *Subjectivities: A History of Self-Representation in Britain, 1832–1920*. New York: Oxford University Press, 1991.

Haug, Frigga and others, *Female Sexualisation*. London: Verso, 1987.

Heron, Liz (ed.), *Truth, Dare or Promise: Girls Growing Up in the Fifties*. London: Virago, 1985.

Hirsch, Marianne (ed.), *The Familial Gaze*. Hanover, NH: University Press of New England, 1998.

Hoggart, Richard, *The Uses of Literacy: Aspects of Working-Class Life, With Special References to Publications and Entertainments*. London: Chatto and Windus, 1957.

Jackson, Brian and Marsden, Dennis, *Education and the Working Class: Some General Themes Raised by a Study of 88 Working-Class Children in a Northern Industrial City*. London: Routledge and Kegan Paul, 1962.

Lewis, Brian and Haring, Colin (eds), *Kept in a Shoebox: the Popular*

Experience of Photography. Castleford: Yorkshire Art Circus, 1992.

Martin, Rosy and Spence, Jo, *Double Exposure: the Minefield of Memory*. London: Photographers Gallery, 1987.

Miller, Nancy K., *Bequest and Betrayal: Memoirs of a Parent's Death*. New York: Oxford University Press, 1996.

Owen, Ursula (ed.), *Fathers: Reflections by Daughters*. London: Virago, 1994.

Radstone, Susannah (ed.), *Memory and Methodology*. London: Berg, 2000.

Rodriguez, Richard, *Hunger of Memory: the Education of Richard Rodriguez: an Autobiography*. New York: Bantam Books, 1983.

Sontag, Susan, *On Photography*. New York: Farrar, Straus & Giroux, 1973.

Spence, Jo, *Cultural Sniping*. London: Routledge, 1995.

Spence, Jo, *Putting Myself in the Picture: a Political, Personal and Photographic Autobiography*. London: Camden Press, 1986.

Spence, Jo and Holland, Patricia (eds), *Family Snaps: the Meanings of Domestic Photography*. London: Virago, 1991.

Steedman, Carolyn, *Landscape for a Good Woman: a Story of Two Lives*. London: Virago, 1986.

Walkerdine, Valerie, *Schoolgirl Fictions*. London: Verso, 1990.